EDUARDO PAOLOZZI

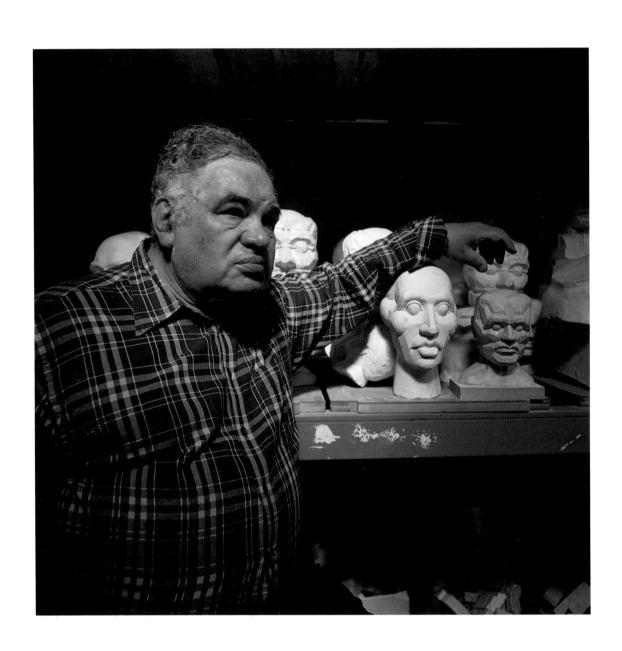

PAOLOZZI

FIONA PEARSON

NATIONAL GALLERIES OF SCOTLAND
EDINBURGH 1999

Published by the Trustees of the National Galleries of Scotland 1999

Text © Trustees of the National Galleries of Scotland
All works © Eduardo Paolozzi 1999. All rights reserved, DACS

ISBN 0 903598 91 4

Designed and typeset in Quadraat Sans by Dalrymple
Printed by BAS Printers, Over Wallop

Cover: detail from *Mein Kölner Dom: Blueprints for a New Museum*

All illustrated works by Eduardo Paolozzi are in the collection of the
Scottish National Gallery of Modern Art, unless otherwise indicated.

Photographic Credits

Maurice Ambler 27; Jorg P. Anders 55; Arts Council of Great Britain 82; N.J. Cotterell
35, 42, 48, 56, 59; Prudence Cuming Associates 19; Edinburgh College of Art 5; David
Farrell 25; Caroline Forbes fig.4; Reinhard Friedrich 24; Nigel Henderson 26; Imperial War
Museum 26; Mark Kauffman 32; Ulrich Mack 40; Jack McKenzie fig.1; Josef Pausch 70;
Snowdon 103; Tate Gallery 17, 18, 50; Konrad P. Taukert 78, 91; Frank Thurston frontis-
piece, fig.2, 22, 77, 79, 86, 99, 101, 102; Victoria & Albert Museum 19; Bernd Wiesen 72.

Illustrations nos. 1, 2, 3, 12, 23, 26, 29, 30, 31, 36, 47, 54, 62, 66, 68,
71, 73, 74, 87 and 94 are uncredited prints held in the Paolozzi Archive
at the Dean Gallery.

All other photographs were taken by Antonia Reeve.

Foreword

The publication of this book celebrates the munificent gift by Sir Eduardo Paolozzi of a large body of his work to the National Galleries of Scotland. It also coincides with the opening of the Dean Gallery, where much of that gift will be displayed, alongside masterpieces of Dada and Surrealism from the Scottish National Gallery of Modern Art's collection. Together with the Paolozzis bequeathed by Gabrielle Keiller, the gallery now has the finest and most comprehensive collection of his work in the world. Of international fame, Sir Eduardo is also a native of Leith, so we are especially proud in Edinburgh to be able to provide a permanent home for his sculptures and archive. We would like to take this opportunity to thank most warmly the artist for his generous gift and for his continued support and interest.

In addition, our grateful thanks are due to the former Lothian Region for making available the building; the Heritage Lottery Fund for funding two-thirds of the refurbishment; and Scottish Office for providing the remainder together with the running costs. Terry Farrell, the architect, has transformed a former orphanage into a magnificent and imaginatively conceived modern art gallery.

We are indebted to all the staff, and colleagues elsewhere, who have worked so hard on this project. Our particular thanks must go to Fiona Pearson, curator at the Scottish National Gallery of Modern Art, who has written this book and over the past four years has catalogued the entire gift and prepared it for display.

TIMOTHY CLIFFORD
Director, National Galleries of Scotland

RICHARD CALVOCORESSI
Keeper, Scottish National Gallery of Modern Art

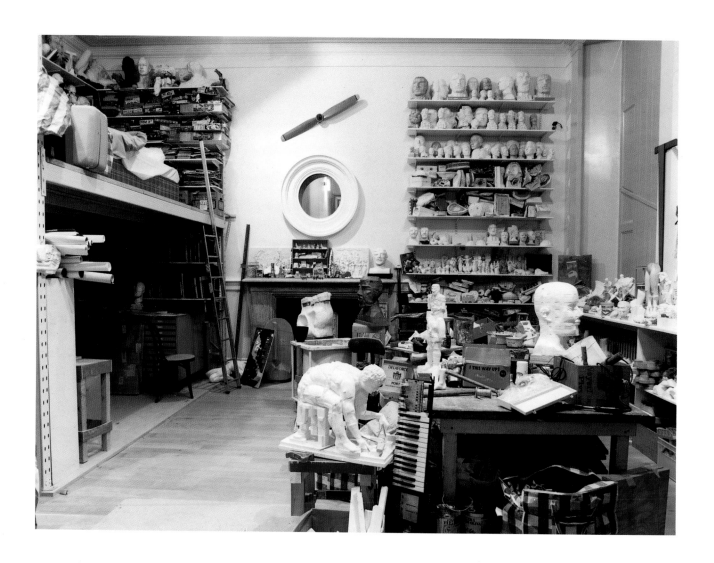

[fig.1] Recreation of the artist's studio in the Dean Gallery, 1999

[fig.2] The artist's studio in London, 1995

Introduction

To counteract and perhaps contradict our tendency to isolate phenomena and impose a separateness of the object, I proposed in a series of prints an idea for a new museum, where in an old building preferably an abandoned cathedral, even a gutted one, there would be a selection from the history of things, the choice of material being an art form; the arrangement and juxtaposition of the objects and sculptures suggesting another philosophy. Not only superb originals but fakes, combined with distinguished 'reproductions', copies of masterpieces both in painting and engineering; the radial engine and a Léger painting, Bugatti wheels, cinema prints, crocodile skulls: all parts movable, an endless set of combinations, a new culture in which problems give way to capabilities.

Eduardo Paolozzi wrote this in 1985 as an introduction to the catalogue of a thought-provoking exhibition at London's Museum of Mankind, entitled *Lost Magic Kingdoms*. Going into Paolozzi's studios in the early 1990s the visitor felt as if this *musée imaginaire* was already halfway to completion (if a little crowded already). Not only did it include finished works in bronze or on paper by the artist, but plaster casts of objects as diverse as the head of Michelangelo's *David*, children's toys and the art of non-western cultures. There were model airplanes, pieces of electronic circuitry, a dismantled musical keyboard; books and magazines on every topic under the sun filled the shelves, while others were in the process of being torn apart for their disparate images. It seemed almost as if the studio were a microcosm of the world outside, as if the artist were trying to give it new meaning, recombining things that ordinarily in the scheme of things would never have been seen together. Here was Hephaestus or Vulcan in his forge, Blake's Newton mapping out the universe, the artist in his traditional role of creator of new worlds.

It was the contents of these studios that Paolozzi promised to the Scottish National Gallery of Modern Art in the spring of 1995. Included in the intended gift were some five thousand sculptures, (mainly plaster), fragments, and works on paper, the studio effects (home-made furniture, tools), rummage boxes of small plaster casts, toys, boxes of tear sheets and manuscripts, an archive of photographs and slides (both of the artist's own works and of things that have interested him throughout his career) and a library of nearly three thousand books and catalogues.

Although most of the sculpture was made in the past two decades, the rest of the material covers the artist's entire career and is thus able to provide an insight into Paolozzi's work and working methods from the 1940s to the present day.

At the end of 1995 the Scottish National Gallery of Modern Art received another exceptionally important gift when Gabrielle Keiller bequeathed to it her remarkable collection of art works and her library of illustrated and artists' books. The twin emphases of this collection were Dada and Surrealism and Paolozzi. The Paolozzi material joined a group of important bronzes by the artist that the Gallery had purchased from Mrs Keiller in the late 1980s and early 1990s. The Paolozzis in the Keiller collection complemented the works in the artist's gift perfectly. Gabrielle Keiller had been Paolozzi's main patron in the 1960s and 1970s and had acquired many of his most important sculptures, collages and drawings from his beginnings in Edinburgh just after the War right up to the mid-1970s.

Thus, in one year, the Gallery had acquired an unrivalled and virtually comprehensive collection of Paolozzi's work. Obviously more space was needed to show this rich fund of material. Fortunately, the City of Edinburgh and Lothian Region were keen to help provide a home for it, since Paolozzi had been born in Leith (Edinburgh's port). They offered to give the National Galleries of Scotland the Dean Centre (formerly Dean Orphan Hospital) which, with

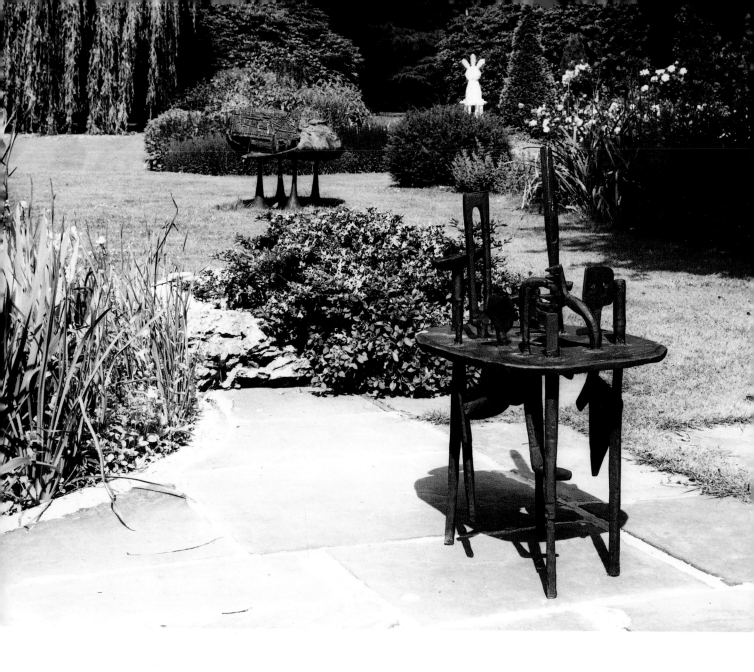

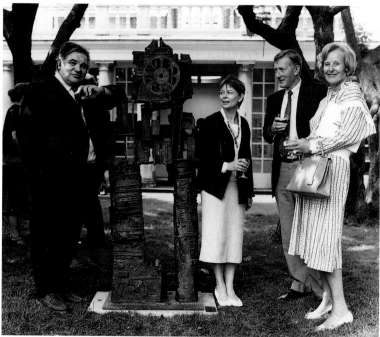

[fig.3] Gabrielle Keiller's garden on Kingston Hill in Surrey, showing, in the foreground, *Table Sculpture (Growth)* 1949, to the left, *Large Frog* 1959, and in the distance, *The Bishop of Kuban* 1962. All three of these sculptures are now in the collection of the Scottish National Gallery of Modern Art (see illustrations 14, 35 and 43).

[fig.4] Eduardo Paolozzi (left) and Gabrielle Keiller (far right) with Paolozzi's *His Majesty the Wheel* 1958 at the private view of *Sculptures from a Garden*, Serpentine Gallery, London, August 1987 (see illustration 39).

imminent local government reorganisation, was due to become surplus to their requirements. Since the building lay directly opposite the Gallery of Modern Art and was a grand neo-classical building by Thomas Hamilton, one of Edinburgh's finest architects, the Galleries were glad to accept such a generous offer. The government subsequently agreed that the Galleries could take on the extra (financial) responsibility for this building and provided money for basic refurbishment. The Heritage Lottery Fund later gave the National Galleries of Scotland an extra £6.3 million to carry out a more imaginative conversion and to help link the Dean Gallery (as it came to be called) with the Gallery of Modern Art.

Early on in the discussions about the Dean Gallery it was agreed that the Paolozzi collection should not be displayed in isolation. It needed a context, indeed changing contexts. Paolozzi himself emphasised the need for contemporary art to be shown in the building; so it was decided to devote the top floor galleries to exhibitions of (mainly) contemporary art. The other context was suggested by the Gabrielle Keiller collection itself and by Paolozzi's own artistic development: namely Dada and Surrealist art. Thus a gallery on the ground floor has been set aside for the Gallery of Modern Art's superb collection of Dada and Surrealism including masterpieces formerly in the collection of Roland Penrose. In addition, adjoining that gallery is a room fitted out in the fashion of a private library in which changing displays of illustrated books, livres d'artiste, periodicals and ephemera related to Dada and Surrealism are shown.

What exactly are Paolozzi's links with the Surrealist movement? He has certainly acknowledged them on several occasions, most notably in a conversation with J. G. Ballard and Frank Whitford in 1971. 'What I like to think I'm doing is an extension of radical Surrealism.'

Surrealism has many aspects, but common to artists and theorists alike was the belief that western civilisation relied too much on reason and divided life into neat and convenient packages rather than attempting, as other cultures – particularly tribal cultures – did, to embrace life's diversity. The Surrealists believed that there was a deeper, some thought higher, reality that united all the phenomena of the world, a reality that we get glimpses of in our dreams. As André Breton put it, in the first Surrealist manifesto of 1924: 'I believe in the future resolution of these two states, dream and reality, which are seemingly so contradictory, into a kind of absolute reality, a surreality, if one may so speak.'

The Surrealist artists attempted to conjure up this absolute reality in a number of ways: by using dream imagery, through automatic drawing, by the use of chance but above all by juxtaposing objects in unlikely combinations. They achieved this last objective by exploiting to the full the collage method, often using pre-existing images found in newspapers, magazines, books and catalogues. This method of working excited Paolozzi's imagination right from the start of his career. Paolozzi had never really believed that there was a special category of figures, objects and situations that were reserved for art, that there were prescribed ways of depicting reality such as were taught at Edinburgh College of Art and the Slade in London. Life was much more heterogeneous and abundant than that. From early childhood, helping in the family confectionery business, he had been fascinated by the colourful and punchy world of advertising and popular culture (sweet wrappers, cigarette cards, comics). Then at the Pitt Rivers Museum in Oxford in 1945 he saw and drew African masks. Amédée Ozenfant's book *Foundations of Modern Art* showed him that there were also artists who were inspired by things as diverse as modern shop-window displays, classical sculpture, microscopic views of diatoms and telescopic views of the solar system. But whereas Ozenfant's Purism sought for common underlying structures and patterns in the world of phenomena, the Surrealists – and Paolozzi with them – revelled in its diversity. This was cause for wonder and it was the duty of the artist to arouse this sentiment in the spectator. Paolozzi's arrival in London in 1944 soon brought him into contact with Surrealist art. At the Slade School of Art where he studied, the teaching was still very traditional but he did become friends with a fellow student, Nigel Henderson, who had actually met several leading Dada and Surrealist artists, including Marcel Duchamp. It was Henderson's knowledge of and enthusiasm for Surrealism that helped set Paolozzi on a path that he is still following today.

Paolozzi began in London to look at Surrealist periodicals (such as *View* and *VVV*), to read Surrealist

exhibitions of Surrealist artists (and artists such as Klee and Picasso who were close to the movement). It was partly the attraction that Surrealism, and especially its open-minded embrace of *différence* had for Paolozzi that caused him to leave London for Paris – the home of Surrealism – in 1947. He explained this attraction in 1985 in conversation with Malcolm McLeod: 'There is a special sort of cognitive experience where a person can look at, and associate disparate things at the same time. I associated this with Paris and that French sensibility which could embrace Dogon masks, pre-Columbian stone sculpture, and ... Baroque churches or modern machinery.' Although the high-water mark of Surrealism had long since passed, postwar Paris still retained powerful vestiges of the movement and Paolozzi sought them out. He visited the studio of Giacometti and met him socially. He saw the rich Dada and Surrealist collections of Mary Reynolds and Tristan Tzara; the former also showed him the room that Marcel Duchamp had papered with pages from the *National Geographic Magazine* (still today this is one of Paolozzi's favourite sources of inspiration). Paolozzi has described the visits to Tristan Tzara as being very special. 'In the apartment was a collage by Picasso – and I recall the newspaper used in the collage had gone bright orange or deep brown – and around it carefully selected African items, mainly Dogon weaving pulleys ... And Tzara might equally show you his African art collection or his *livres deluxe*, specially hand printed and bound editions of his own poems.' In Tzara's apartment he also saw a number of early collages by Max Ernst including the famous *Chinese Nightingale* 1920, which made a particular impression on him. The work is made up of a number of collaged body parts, a fan and machinery that prefigure Paolozzi's own later use of mechanised figures, robots and automata.

Several exhibitions that Paolozzi saw in Paris at this time reinforced his interest in the Surrealist use of collage: notably, the famous show *Le Surréalisme en 1947*, organised by André Breton and Marcel Duchamp at the Galerie Maeght, and as many as three shows of the work of Francis Picabia. Again, Picabia's mechanisation of the human body proved a strong attraction to Paolozzi.

Paris was also an excellent place to buy old copies of the pre-war Surrealist and other reviews such as *Minotaure* and *Cahiers d'Art*, and Paolozzi

made full use of of the second-hand bookshops to do this. What attracted him to these publications was the vitality and diversity of the illustrations: from mediaeval art, through the most recent developments of Surrealism, from African masks to automata and Hollywood films. Magazines such as these proved a rich source of material to feed both Paolozzi's imagination and, after his return to London, his art. Significantly it was in the Surrealist reviews (*Minotaure, Variétés* and especially *Documents*) that serious scholarly and artistic attention was paid to popular culture: to comics, science fiction and fantasy novels, to popular entertainment, music and films. These subjects, previously considered merely shallow and derivative, were now being treated on a par with so-called 'high' art in a quasi-anthropological manner.

This rich Surrealist heritage that Paolozzi explored in Paris was to prove the main catalyst to the artistic breakthrough that he achieved in the early 1950s when back in London. If Paolozzi's famous *Bunk* 'lecture', given to the Independent Group at the Institute of Contemporary Arts in 1952, is with some reason cited as the birthplace of British Pop art, it is also the logical outcome of the Surrealists' search for an all-embracing approach to culture. Paolozzi used an overhead projector to show images of a myriad world torn seemingly at random from illustrated magazines, adverts, sale catalogues, scientific publications, art books and many other sources. No commentary accompanied the images. The effect intended and by all accounts achieved was one of visual disorientation and overload. But the unspoken implications were enormous and far-reaching. If there was, from now on, to be no hierarchy of subject-matter, style or type of image, then the artist had almost unlimited freedom to combine and interpret the world as he wished. Paolozzi did not shy from these conclusions. The complexity and visual richness of his subsequent work are testimony to that.

KEITH HARTLEY
Assistant Keeper, Scottish National Gallery of Modern Art

Eduardo Paolozzi

Early Life

Eduardo Paolozzi was the eldest child of immigrant Italians based in the port of Leith near Edinburgh. His mother, Carmela Rossi, had been raised in Leith where her parents ran a confectioner's business. On a visit to their Italian home town of Viticuso she met and fell in love with Alfonso Paolozzi,[1] who had to do his national service (1918–20) before they could consider marriage. He subsequently came to Scotland and in 1922 they were married [1]. Sponsored by his father-in-law, Pietro Rossi,[2] Alfonso ran a confectioner's shop at Seafield Hospital for the first three years of his married life. On 7 March 1924 Eduardo Luigi Paolozzi was born at 6 Crown Place next to Leith Central Station.[3] In 1925 Alfonso Paolozzi took over the tenancy of a confectioner's shop at 10 Albert Street.[4] In 1928 Eduardo Paolozzi began school at Leith Walk Primary School where he spoke Scots in the playground. At home he spoke the peasant Italian of his parents and at weekends he learnt standard Italian.

The Paolozzi family were part of the extensive Italian Scots community in Edinburgh. From the age of nine until the outbreak of War, Eduardo, along with other Italian children, was sent for three months every summer to a Fascist youth camp in Italy [2]. The regime of camp life and open air gymnastics provided a welcome break from the long days during term time. On return from school Paolozzi was expected to work in the shop and perform numerous tasks until the shop shut at about eleven at night [3].

Alfonso Paolozzi was a creative man who made radios for every room in the Paolozzi flat. So began Paolozzi's lifelong dependence upon the radio for information and entertainment. His imagination was fed not only by the radio but also by weekly trips to the cinema. Nothing was wasted in the Paolozzi household and the young Paolozzi drew on recycled wrapping paper from the confectionery business [4], fascinated by its bright colours and imagery. He made tracings and cut out images that appealed to him from magazines and comics. These he made into scrapbooks. He was also fascinated by aeroplanes and had a passion for making models from kits. He has said that his first sculpture was when he made a facsimile of a propeller in wood.[5]

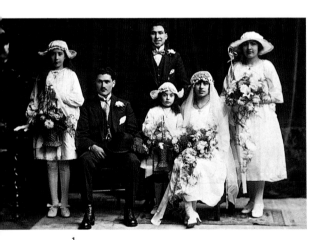

1

2

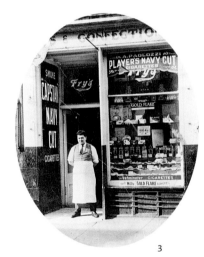

3

1922
16 November: marriage of Alfonso Paolozzi and Carmela Rossi.

1924
At 4.30pm on 7 March Eduardo Luigi Paolozzi born.

1925
Alfonso Paolozzi took over the shop at 10 Albert Street.

1928
Eduardo Paolozzi began school at Leith Walk Primary School where he stayed until he was twelve.

c.1933
Began attending summer youth camps in Italy run by the Fascist Party. He attended every year until the outbreak of War in 1939.

1936
Began school at Holy Cross Academy, Leith, where he stayed until 1940.

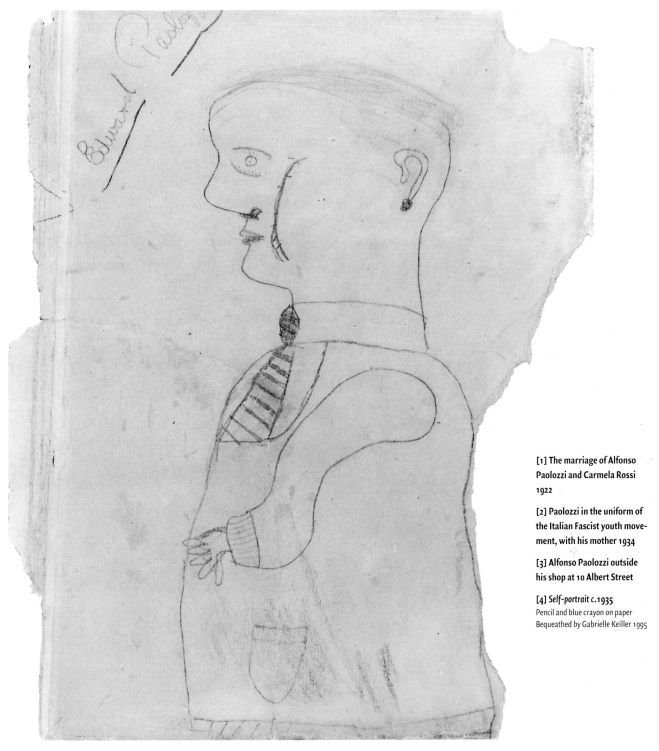

[1] The marriage of Alfonso Paolozzi and Carmela Rossi 1922

[2] Paolozzi in the uniform of the Italian Fascist youth movement, with his mother 1934

[3] Alfonso Paolozzi outside his shop at 10 Albert Street

[4] *Self-portrait c.*1935
Pencil and blue crayon on paper
Bequeathed by Gabrielle Keiller 1995

4

War Years

In 1940 Paolozzi's routine existence was shattered by the entry of Italy into the Second World War. There was a degree of public hostility towards so-called 'enemy aliens' and the Paolozzi shop was looted. Within twenty-four hours his father, Alfonso Paolozzi, his maternal grandfather, Pietro Rossi, and an uncle were taken away by the police. Tragedy ensued when the ship taking them to internment in Canada, the ss *Arandora Star*, was torpedoed and all three were drowned. Eduardo Paolozzi, aged sixteen, was himself taken by the police and interned in Saughton Prison for three months. His mother and sister were forced to move to Innerleithen, away from the coast. After three months in internment Paolozzi was allowed back to the shop in Albert Street where his mother and sister rejoined him. Together they ran the shop and made the ice cream. In order to bring in extra money Paolozzi left school and found work, first at a tea warehouse and then as a motor mechanic. It was as a mechanic that he first registered for evening classes at Edinburgh College of Art in 1941.[6]

Paolozzi's initial ambition was to be a commercial artist.[7] He took his scrapbooks and tracings along to Edinburgh College of Art and was admitted on that basis. His first task was to draw from a cast collection of masterpieces from Greece and Rome and from reproductions of mainstream European art and architecture [5]. Paolozzi remembers that the first casts he encountered were details from Michelangelo's *David*. Paolozzi was taught sculpture by Norman Forrest and painting by John Maxwell. Early in 1943 he signed up at the College for a full-time course. We know also that he was taught letter-cutting in stone. However, all this was interrupted by the arrival of his call-up papers in June 1943.

Paolozzi entered 270A Company of the Pioneer Corps and was sent to Bradford for basic army training. The Pioneer Corps was drawn from foreign nationals and Paolozzi found himself serving with a substantial number of Italians, including three uncles. They were later sent for training in Slough, which was close enough to London to allow him to attend classes at St Martin's School of Art on his leave days. Paolozzi persisted with his art at the army camp. He drew his fellow soldiers [6], his bunk and spare parts of motor bikes. In these drawings he consciously tried to copy the style of Leonardo da Vinci. However, while posted to Buxton in Derbyshire, Paolozzi discovered a book that was to change his life. Amédée Ozenfant's *Foundations of Modern Art* gave him a new conception of art [7]. He later said: 'It showed aeroplanes, and Zulus and Greek architecture and actresses all in one volume, whereas before I had thought art to be beyond some unbridgeable gulf.'[8] Ozenfant looked at the constants of humanity in literature, art, music and science and provided a vivid introduction to the modern movement in art from Cubism to Surrealism. Paolozzi understood that his own interests and experiences could be used in pursuit of art and so determined to become an artist.

[5] **The cast court at Edinburgh College of Art** *c.*1914–15
Photograph courtesy of the Chairman and Board of Governors of Edinburgh College of Art

[6] *Soldiers Playing Cards* 1944
Pen, ink and wash on paper
Courtesy of the Trustees of the Imperial War Museum

[7] **Amédée Ozenfant, Foundations of Modern Art**
Plate from 1931 edition entitled *A Surprise: The Outskirts of Cairo as Seen from an Aeroplane*

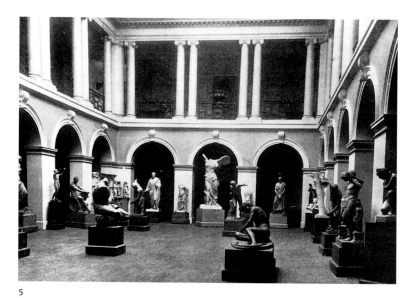

5

1939
September: War declared.

1940
On 10 June Italy entered the War and the Paolozzi shop was looted.

1941
Studied in the evenings at Edinburgh College of Art, drawing from the life and from plaster casts, and cutting letters in stone. His teachers included Norman Forrest (sculpture) and John Maxwell (painting). Made scrapbooks of images cut from magazines.

1943
In January began to study full-time at Edinburgh College of Art. In June received call-up papers to join the 270A Company of the Pioneer Corps.

1944
In August discharged from the army as psychologically unsuitable. Attended Ruskin School of Drawing in Oxford. Visited Kurt Schwitters exhibition.

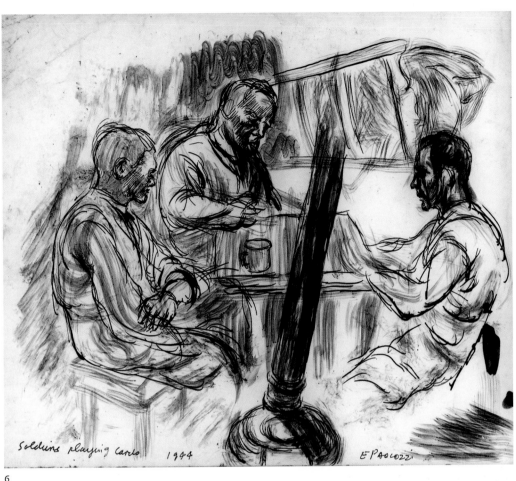

Soldiers playing Cards 1944 E PAOLOZZI

6

7

Oxford and London

During August 1944 Paolozzi was granted an early discharge from the army on the grounds of being psychologically unfit. He had feigned madness in order to achieve this end.[9] He had learnt while at St Martin's that the Slade had been evacuated to the Ruskin School of Drawing in Oxford. He therefore went to Oxford where he studied first with Albert Rutherston at the Ruskin, who he said liked the idea of 'rough blood' tempering the gentility of his classes. He then transferred to the Slade, which had a sculpture school. Paolozzi later said of the transfer: 'I just felt I wanted to make things.' He was taken on without having to pay fees on the condition that he work as a fire watcher. He slept in the Ashmolean Museum and in addition earned four shillings and sixpence a night. During this period he drew from reproductions of Rembrandt [8] and Dürer in the Ashmolean and studied the ethnographic collection of the Pitt Rivers Museum. Fellow students at the Slade included Raymond Mason and Peter de Francia. In 1944 he saw a Kurt Schwitters exhibition at the Modern Art Gallery, London, that encouraged him to continue with his scrapbooks and to start working in collage. The famous exhibition of Picasso and Matisse at the Victoria and Albert Museum in 1945 gave him the impetus to draw in a new style that owed much to Picasso [9].

Paolozzi stayed one year at Oxford and when the Slade moved back to London in 1945 he returned with them as a pupil of the sculpture school. The conservative head of the school was called A. H. Gerrard who was later remembered for his kind nature and his talent for reclaiming material from bomb sites.[10] This kind of scavenging way of working informed Paolozzi's early sculptures in concrete, to which he added such found objects as meat bones. Paolozzi later remarked that the teachers at the Slade were sweet people but not obsessed by the pursuit of their art. As a result of this tepid atmosphere he chose to stay away from the college and work in the basement of his student digs at 28 Cartwright Gardens near King's Cross. He also drew in the Science Museum, following on his interest in things mechanical.

[8] *Copies from Rembrandt, Ashmolean Museum, Oxford 1945*
Pen and ink on paper
Bequeathed by Gabrielle Keiller 1995

[9] *Crab Fishermen 1946*
Ink on paper
Bequeathed by Gabrielle Keiller 1995

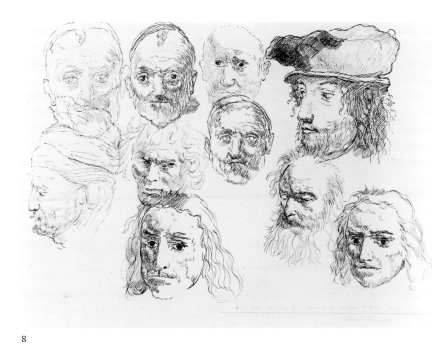

8

1945

On 31 April registered to study at the Slade which moved back to London later that year. Prior to the start of term worked in marble-mason's workshop making tombstones. Influenced by Ernest Hemingway and Picasso, carved and made bulls and bulls' heads. At Slade met William Turnbull and Nigel Henderson. Through Nigel Henderson's mother Wyn met John Davenport and Freddie Mayor of the Mayor Gallery. Saw modern work in the houses of John Davenport and Roland Penrose. Visited the London Gallery, met Peter Watson, who was an early mentor. During his time at the Slade met Freda Elliott.

1946

Made and cast some of his concrete animals in the basement of 28 Cartwright Gardens. Produced Picassoesque pen and ink drawings of fishermen, drawn after visits to Newhaven Harbour in Edinburgh. Began to make collages marrying photographs of traditional sculpture with machine elements.

1947

14 January–1 February, first one-man exhibition at the Mayor Gallery, London, which sold well and was reviewed favourably by Robert Melville in *Horizon* magazine. Made £75 and with these proceeds left to live in Paris, in the footsteps of Raymond Mason. Took with him

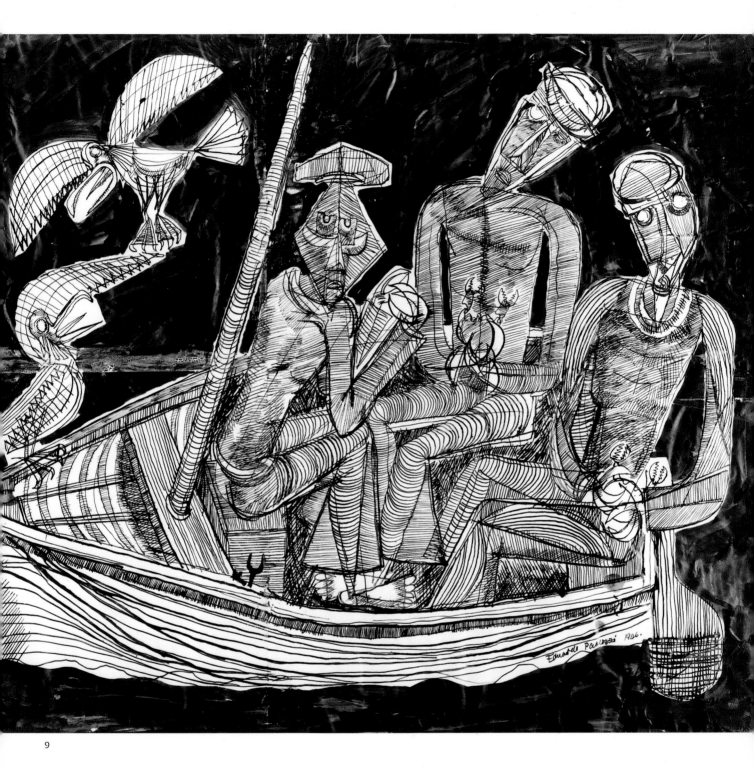

9

a bicycle, a frying pan, a big tin trunk and a plate camera. Rented a room on the Île St Louis for £1 a month. A painter let him rent a room at 16 rue Visconti as a studio. Formally enrolled at the École des Beaux Arts but worked in his own studio. Made small reliefs modelled in the negative. Went on to make sculptures such as *Forms on a Bow* and *Two Forms on a Rod*. Met Giacometti, Brancusi, Léger, Braque, Hélion, Arp, Balthus, Mary Reynolds and Tristan Tzara. Studied Surrealism, Dubuffet and *art brut*. Made coloured paper collages of lottery and fair booths. Léger arranged a screening of his *Le Ballet Mécanique*. Saw *Le Surréalisme en 1947* exhibition at the Galerie Maeght.

1948
3–21 February, second one-man exhibition at Mayor Gallery consisting of collages and drawings of lottery and fair scenes. Nigel Henderson visited him in Paris and took him to meet Peggy Guggenheim where he also met Jean Arp. Stayed with Margaret Gardiner on short visits to London. Created fish, land and insect reliefs. Visit to Viticuso in Italy in the summer with Freda Elliott. Inspired by D'Arcy Wentworth Thompson's book *On Growth and Form*.

The Modern Movement

Paolozzi shared an enthusiasm for modern developments in art, literature and popular culture with his fellow Slade students Nigel Henderson, Raymond Mason and William Turnbull. Henderson in particular was a direct link with the modern movement. His mother Wyn Henderson had run Peggy Guggenheim's London Gallery, Guggenheim-Jeune, in 1938–9. Nigel Henderson, having helped Marcel Duchamp hang an exhibition at Guggenheim-Jeune, became the owner of a Duchamp *Green Box*. The box of writings became a talisman for Henderson and his circle. Paolozzi was perhaps more influenced by Duchamp's *Boîte-en-valise* which was a sort of *musée imaginaire* containing miniature versions of Duchamp's own works. Even to this day Paolozzi makes boxes including writings, tearsheets, reproductions of works of art, books and CDs for friends and colleagues.

Henderson introduced Paolozzi to Surrealism through the auspices of the London Gallery, run by E. T. L. Mesens. The main backer of the London Gallery was the British Surrealist, patron and writer, Roland Penrose. It was through Penrose that Paolozzi became acquainted with the work of Picasso at first hand. Selected works from Penrose's collection were shown at the London Gallery and Paolozzi also visited Penrose's Hampstead house through the offices of Penrose's neighbour, Margaret Gardiner. Other collectors he met included Peter Watson and John Davenport. At this time Paolozzi was inspired to work in a Picassoesque manner [10] but he was also influenced by works in these private collections by Max Ernst and Alberto Giacometti.

Key texts that Paolozzi studied while at the Slade were André Breton's *What is Surrealism?* and Herbert Read's *Art Now*. In his copies of both these publications Paolozzi made marks and annotations.[11] In the latter he noted particularly passages on empathy, the psychology of modern art, language and spontaneity of expression. Paolozzi was by this time beginning to develop a Surrealist aesthetic which saw beauty in the strange and the bizarre. He also developed an interest in the art of children, the insane and prisoners. The modern movement was fascinated by the 'primitive' and Paolozzi was particularly attracted to primitive art in whatever context it occurred.

Wyn Henderson introduced Paolozzi to Freddie Mayor (founder of the Mayor Gallery), who gave him his first one-man show in 1947 while Paolozzi was still a student at the Slade. He exhibited sculptures of birds, fish and animals in plaster, concrete and bone. The works, which included sculptures of bulls and bulls' heads, show the influence of Picasso but also evince an interest in the writings of Ernest

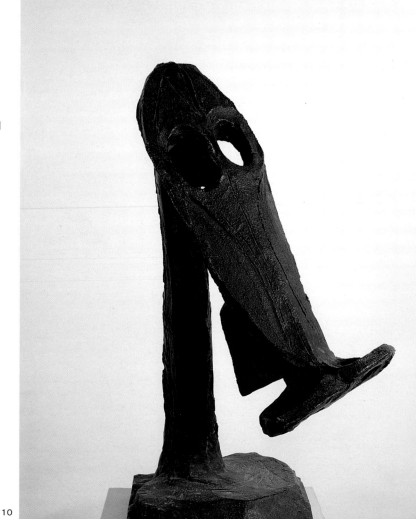

[10] *Horse's Head* 1946
Bronze
Purchased from Gabrielle Keiller
1993

[11] *Bull* 1946
Bronze
Bequeathed by Gabrielle Keiller 1995

[12] *Nike de Paionios* 1946
Collage
Private Collection

10

Hemingway [11]. It was at this point that he began to work intensively in collage, a form of image-making that has remained central to his *oeuvre* (both in works on paper and sculpture). He began by making collages which married antique or traditional, turn-of-the-century sculpture with machine imagery [12].[12] These were inspired by Max Ernst's collages of 1919 and the early 1920s. During 1946 he began to make scrapbooks of found images of pin-up girls, food, vehicles and luxury goods taken from glossy magazines. These activities were divorced from the classes at the Slade where Alfred Munnings and Augustus John were still the artistic heroes. The success of Paolozzi's 1947 exhibition enabled him to quit the Slade that summer and to go to Paris. He later spoke of the grey austerity of London and his wish to follow his friend Raymond Mason to the home of the modern movement.

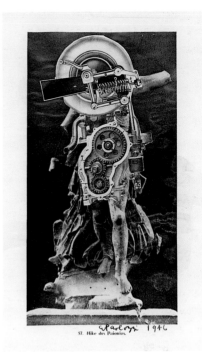

12

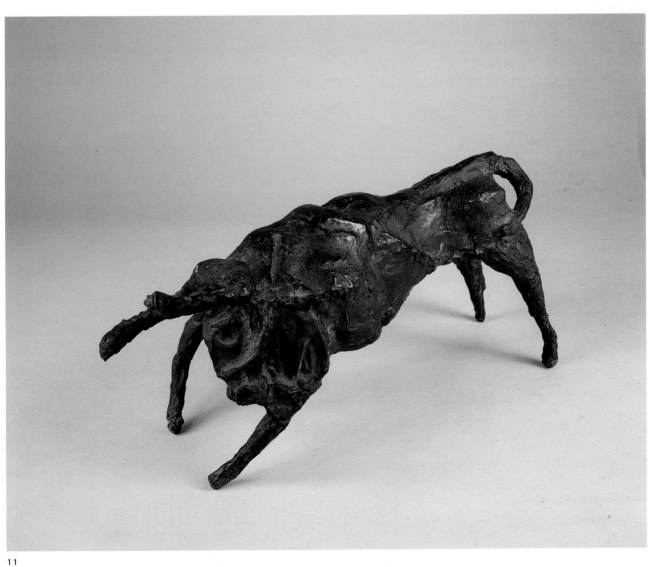

Paris

Paolozzi rented a room from Mason on the Île St Louis and found a studio at 16 rue Visconti, near the École des Beaux Arts, at which he registered. He was not, however, a regular attender; he chose instead to learn at first hand from the modern masters resident in Paris. William Turnbull, who was in Paris at this time, accompanied him on many of his studio visits. The greatest influence on Paolozzi was Alberto Giacometti, whom he met many times and whose studio he visited. Fernand Léger was very approachable and arranged for him to see his film, *Le Ballet Mécanique*. Paolozzi also met Arp, Hélion, Braque, Calder and Brancusi. Two other influential contacts were the Surrealist poet Tristan Tzara and Mary Reynolds. Tzara, whose collection included collages, frottages and drawings by Max Ernst, gave Paolozzi access to his own library which was full of Dada and Surrealist books and periodicals. Reynolds allowed him to see Duchamp's studio and library. Paolozzi was also fascinated by the machine imagery and Dadaist wit of Francis Picabia. Perhaps his most important discovery was the work of Jean Dubuffet, both as a primitivising artist and as a collector of *art brut*. Dubuffet was to become a major influence on Paolozzi in the 1950s.

The first objects Paolozzi made in Paris were in clay. They were small reliefs, influenced by Klee's use of pattern, modelled in the negative because he could not afford to produce casts. The method also allowed a direct handling of the material. The biomorphic shapes in the animal sculptures of Picasso, the Surrealist works of Giacometti and the drawings of Paul Klee were a rich source for Paolozzi's Paris sculptures such as *Two Forms on a Rod* [13], *Table Sculpture (Growth)* [14] and *Paris Bird* [15]. He studied sculpture in the Egyptian section of the Louvre, marvelling at the use of tiny animals,[13]

and admired the wide range of exotic artefacts in the ethnographic collections of the Musée de l'Homme. He was fascinated by the bright street life of fairgrounds, shooting booths [16] and lottery stands and made drawings and collages of these subjects. These works employed formal pattern-making in pen and ink and incorporated geometric shapes cut out of coloured paper. Paolozzi also continued to make clippings for scrapbooks from magazines such as *Look*, *Life* and *Esquire*, which he obtained from American GIs in Paris. *I was a Rich Man's Plaything* 1947 [17] and *It's a Psychological Fact Pleasure Helps Your Disposition* 1948 [18] come from a large body of work made at this time. The collages were followed by a series of titled scrapbooks, the first being the *Psychological Atlas* of 1949 [19], filled with Surrealist-inspired collages that juxtapose things such as Renaissance sculpture and train wagons to create extraordinary images.

[13] *Two Forms on a Rod* 1948–9
Bronze
Purchased from Gabrielle Keiller
1988

[14] *Table Sculpture (Growth)* 1949
Bronze
Purchased from Gabrielle Keiller
1988

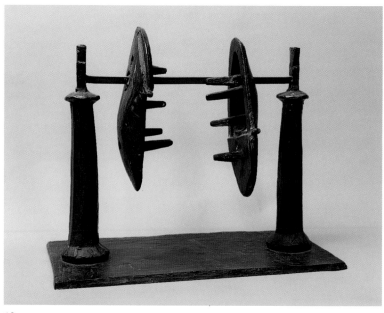

13

1949

Showed in *Réalités Nouvelles 4ème Salon* at the Palais des Beaux Arts de la Ville de Paris. Woodblock printing and cloth printing. Fascinated by Parisian fish shops. Third one-man show at Mayor Gallery 10–31 May following a visit to St Jean de Luz. Show consisted of plaster reliefs that evoked the seaside and lunar landscapes. Works bought by Peter Watson, Peter (E. C.) Gregory and Roland Penrose but show not an overall success. Forced to return to London towards the end of the year and to take up a teaching career. Brought back from Paris portfolios of images that he thought were bizarre and abnormal, as well as an enlarger for Nigel Henderson. Back in London, lived in Bethnal Green (Chisenhale Road) with Nigel and Janet Henderson and borrowed a studio from Olive Richmond at Radnor Walk in Chelsea, which he shared with William Turnbull. Often saw Francis Bacon. Later lodged with Lucian Freud and his first wife, Kitty Garman, in St John's Wood, then in Hampstead with Margaret Gardiner next door to Roland Penrose and also with Kathleen Raine in Paultons Square, Chelsea. Made *Psychological Atlas* scrapbook.

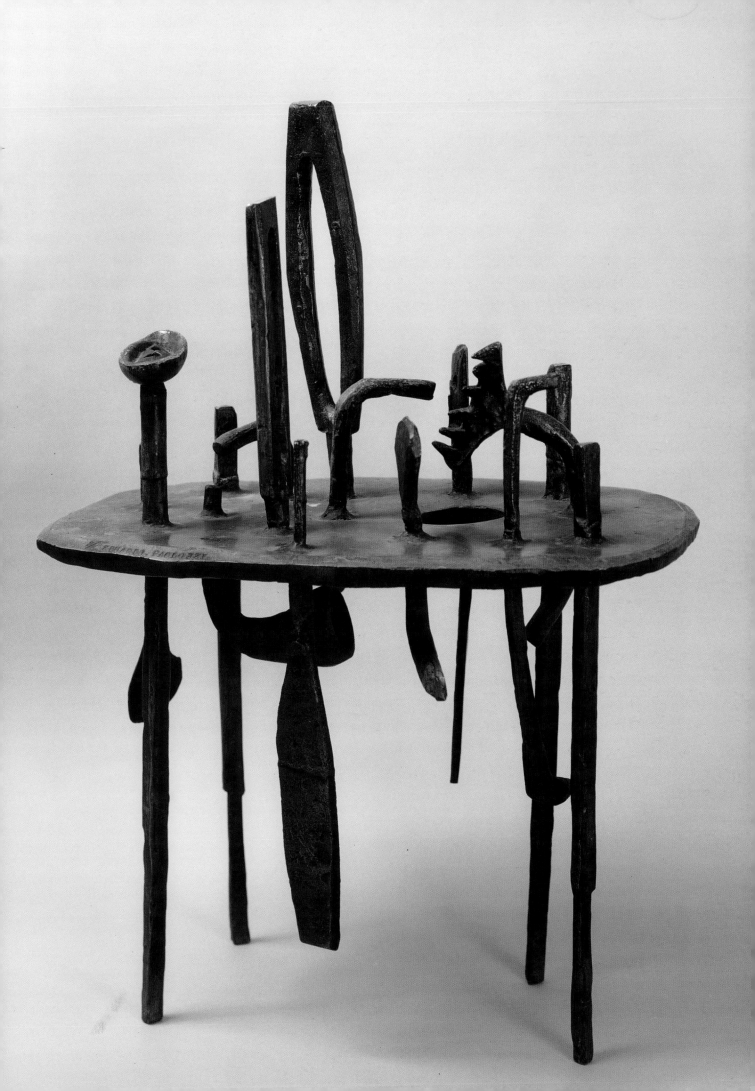

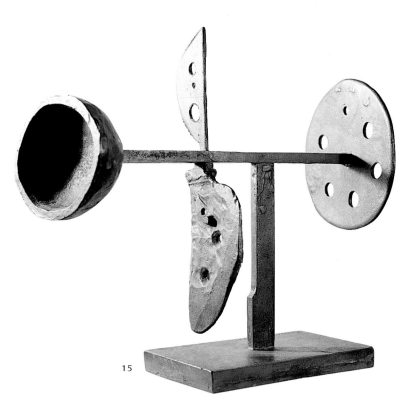

15

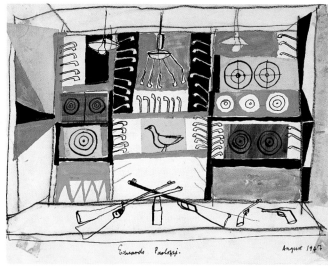

16

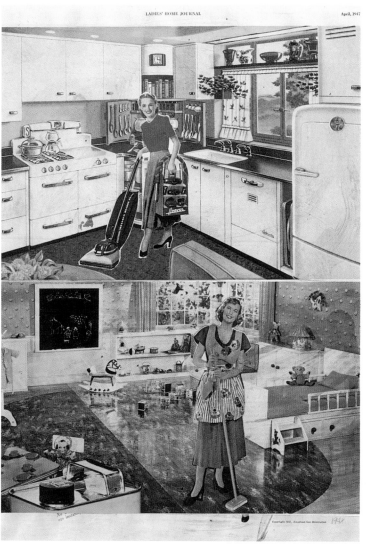

19

18

[15] *Paris Bird* 1948–9
Bronze
Purchased 1987

[16] *Shooting Gallery* 1947
Ink, gouache, black chalk and collage on paper
Bequeathed by Gabrielle Keiller 1995

[17] *I Was a Rich Man's Plaything* 1949
Collage
Courtesy of the Trustees of the Tate Gallery, London

[18] *It's a Psychological Fact Pleasure Helps Your Disposition* 1948
Collage
Courtesy of the Trustees of the Tate Gallery, London

[19] *Psychological Atlas* 1949
Page from scrapbook
Courtesy of the Trustees of the Victoria & Albert Museum, London (on loan from the artist)

Central School of Art and Design

In 1948 Paolozzi received an invitation from William Johnstone, Principal of the Central School of Art and Design in London, to teach sculpture. He declined and stayed on in Paris for another year. Paolozzi had two more shows at the Mayor Gallery, in 1948 and 1949, hoping that they would provide the funds to support his continued stay in Paris. Unhappily the 1949 exhibition, which included reliefs that evoke marine or lunar landscapes, was not well received. Only Roland Penrose, Peter Watson and Peter (E. C.) Gregory bought works. Paolozzi was forced to return to London and was given a post at the Central School teaching textile design.[14] He stayed there from 1949 to 1955 and during that time made many screenprints based on drawings with the help of his friend and colleague Anton Ehrenzweig [20]. Research and inventiveness were encouraged in the textile department, whose staff included Hans Tisdall.[15] Other staff in the college at that time were Victor Pasmore, Alan Davie, William Turnbull, Richard Hamilton and Nigel Henderson.

Paolozzi had visited Jean Arp in 1948 and saw his work *After Torn Papers*, literally torn paper collages where the process of the work suggests transience in life. As a result of this, (and inspired also by the work of Schwitters), Paolozzi developed a new collage style, using printed ephemera, scraps of printed designs and drawings [21]. In about 1952 he invented another collage technique which introduced horizontal and vertical cuts to dissect and re-assemble disparate head elements from *Time* magazine covers [22].[16] Thus began a lifelong interest in deconstruction and reconstruction. At this period Paolozzi got to know the architects Jane Drew, Maxwell Fry and Alison and Peter Smithson. They were influential on his thinking for his commissioned *Fountain* for the Festival of Britain [23], *Study for a Children's Playground* and a patterned *Ceiling Decoration* for the offices of Fry, Drew and Partners. Paolozzi was keen to work with architects to create whole environments. His interest in architecture, from Mayan civilisations to the work of Frank Lloyd Wright, has informed all his public commissions.[17] In 1952 he entered the international competition for *A Monument to the Unknown Political Prisoner* [24]. His entry consisted of an installation of incised rectangular blocks set in an architectural complex that suggests enclosure and isolation. There were 500 British entries out of a total of 3,500 from fifty-seven countries and Paolozzi was one of twelve British finalists shown in London in 1953. The competition marked an important stage in the development of postwar British sculpture with the emergence of a new aesthetic informed by a knowledge of Auschwitz and Hiroshima.[18] This meant a language of forms suggesting decay, tension, deformity and fear. Paolozzi had in 1951 made a sculpture called *The Cage* for the Festival of Britain that explored some of these issues [25].

Paolozzi led an unsettled life after his return from Paris. He had formed a friendship with Freda Elliott and she had followed him to Paris. On his return he stayed variously with Nigel Henderson, the painter Lucian Freud and the collector Margaret Gardiner, all friends and supporters of his work. Paolozzi's friendship with Henderson gave him an anthropological slant on the world around him. Henderson and his wife were close observers of their local community in Bethnal Green. Henderson took a series of photographs documenting the street life over a number of years and his wife wrote an anthropological thesis about the locality.[19] This scientific way of looking at society still informs Paolozzi's approach to people and situations. He spoke of the

[20] *London Zoo Aquarium* 1951
Ink and watercolour on paper
(source for a screenprint)
Bequeathed by Gabrielle Keiller 1995

[21] *Collage* 1953
Collage on paper
Bequeathed by Gabrielle Keiller 1995

1949–55
Taught textile design at Central School of Art and Design at the invitation of William Johnstone. After classes he would descend to the Ceramic Department and make terracotta reliefs.

1950
Began to mix with Jane Drew and Maxwell Fry, Peter and Alison Smithson, Reyner Banham, Lawrence Alloway and Toni del Renzio at the Institute of Contemporary Arts. Screenprinting experiments with Anton Ehrenzweig at Central School and at London College of Print-ing. Made a sculpture after a dummy head, called *Mr Cruikshank* based upon source material he pasted into *Crane and Hoist Engineering* scrapbook. Conversation with Albert Einstein, a personal hero, on *weltschmerz*. Lived at 58 Holland Road, Shepherd's Bush.

Asked by Drew to decorate bar at ICA and through her commissioned to make a fountain for the Festival of Britain the following year.

1951
Married Freda Elliott and went to live in Paultons Square in Chelsea. Made wire sculptures, such as *The Cage*, an important commission for the Arts Council of Great Britain. Monumental *Fountain* construction in steel and concrete exhibited at Festival of Britain, London.

20

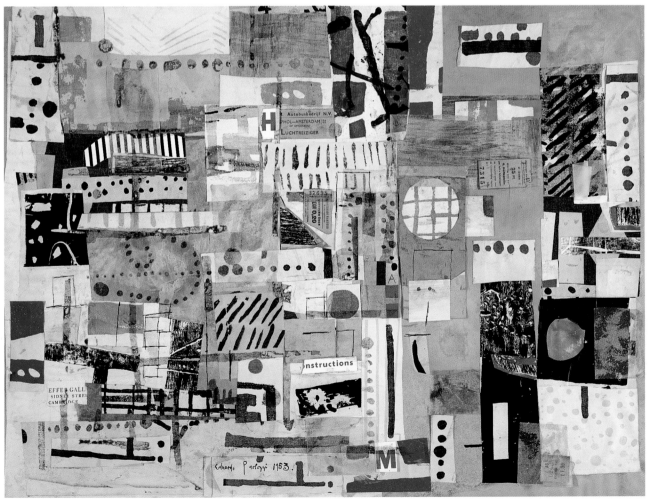

21

[22] *Keep it Simple, Keep it Sexy,*
Keep it Sad 1952
Collage on paper
Courtesy of the artist

[23] *Fountain commissioned for*
the Festival of Britain 1951

[24] *Maquette for a Monument to*
the Unknown Political Prisoner
1952
Plaster
Colin St John Wilson Collection

[25] *The Cage* 1951
Wire and plaster
(Bronze in Arts Council Collection)

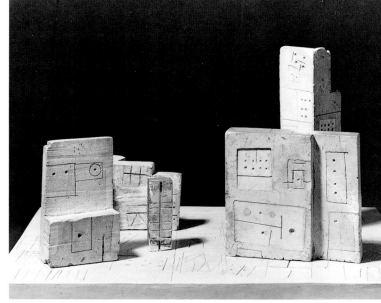

24

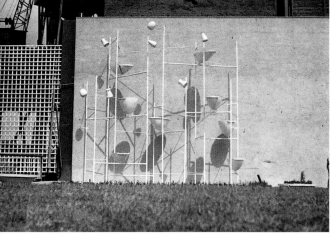

23

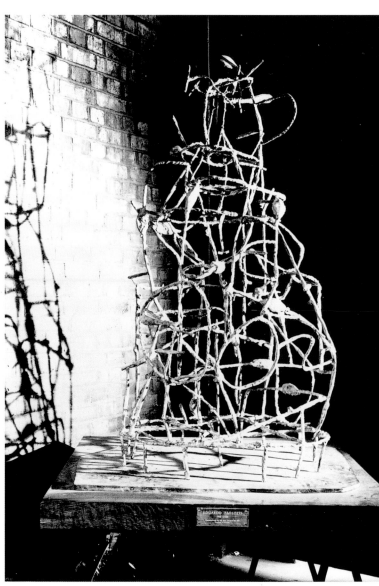

25

`This is TIME's Issue of August 11, 1947`

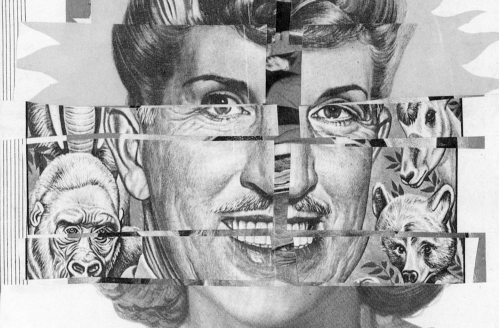

ATLANTIC OVERSEAS EDITION

TIME

THE WEEKLY 　　 AZINE

Boris Chaliapin

ROSEMARY CLOONEY
Keep it simple, keep it sexy, keep it sad.

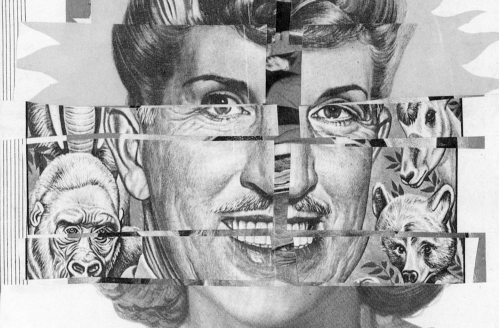

	.5 schilling	FINLAND	60 finmarks	IRELAND	1/6	SOUTH AFRICA	
	12 francs	FRANCE	80 francs	ISRAEL	.200 prutot	SPAIN	10
SLES	1/6	FRENCH POSSESSIONS	85 francs	ITALY	.150 lire	SWEDEN	1:25
POSSESSIONS	2/–	GERMANY	1 deutschmark	LEBANON & SYRIA	100 piastres	SWITZERLAND	1,10
	1 shilling 6 piastres	GREECE	4000 drachmai	NETHERLANDS	.90 cent	TURKEY	85
K	1:50 kroner	IRAN	25 rials	NORWAY	1:50 kroner	YUGOSLAVIA	.90
	10 piastres	IRAQ	100 fils	PORTUGAL	.7 escudos		

OPY PRICE:
. . . 2.50 schillings
. . . 12 francs
. . . 1 shilling
. . . 15 korun
. . . 1:25 kroner
. . . 40 finmarks
. . . 25 francs
. . . 2.50 reichsmarks
. . . 1250 drachmai
. . . 60 lire
. . . 65 cent
. . . 1:30 kroner
. . . 30 zlotys
. . . 7 escudos
. . . 1 krona
. . . 1 franc 10 centimes

PORTUGAL 7 escudos
SWEDEN 1 krona
SWITZERLAND 1 franc 10 centimes
MEMBERS U.S. ARMED FORCES . . 20 cents

VOL. I NO. 6 (REG. U. S. PAT. OFF.)

22

culture shock as he moved from district to district in London. At last he found a home in Holland Road, Shepherd's Bush and shared a studio at Radnor Walk, Chelsea with William Turnbull. In 1951 Paolozzi married Freda Elliott [26] and they went to live at Paultons Square as tenants of Kathleen Raine, the William Blake scholar and poet. Raine had been part of a group in Cambridge which was the first in Britain to realise the importance of Surrealism. Paolozzi decorated Raine's house with textiles and wallpapers of his own design. He used bold pattern-making based upon simple graphic lines, dots and dashes. These had a primitive character which Paolozzi repeated in his decoration of ceramic heads. Four years later he was to found the firm Hammer Prints with Nigel Henderson for the manufacture of textiles, wallpaper, tapestries and ceramics.[20] He was interested in the possibility of making a complete environment reminiscent of the Bauhaus and Arts and Crafts ideals.

Many of Paolozzi's sculptures at this time were open wire configurations or pod-like forms that were presented as indeterminate biomorphs or heads. He also had a fascination for Mexican papier-mâché dummies and made his own dummy-sculptures [27]. Apart from his papier-mâché figures, the first proper dummy-sculpture was *Mr Cruikshank* of 1950. It was based on a dummy used by the Massachusetts Institute of Technology for the measurement of radiation on the human head [28], but here Paolozzi is also conscious of a fascination with dolls, dummies and automata shared by twentieth-century artists from de Chirico onwards.

Paolozzi's first international exposure came at the Venice Biennale of 1952 when he was shown in the British Pavilion with young contemporaries Kenneth Armitage, Geoffrey Clarke, William Turnbull, Robert Adams, Reg Butler, Lynn Chadwick and Bernard Meadows, in conjunction with the well-established Henry Moore. It was a ground-breaking

exhibition, introducing the new generation of British exponents of 'existentialist' sculpture, for which Herbert Read in the catalogue coined the phrase 'the geometry of fear'.[21] Paolozzi and Nigel Henderson visited Italy to see the exhibition and were entertained to dinner by Peggy Guggenheim. They then went on to Naples where Paolozzi revelled in the street life during the feast of the city's patron saint. The main attraction, however, was the famous aquarium which inspired a whole series of screenprints. The final port of call was a visit to Viticuso, the home of Paolozzi's relatives, near Monte Cassino.

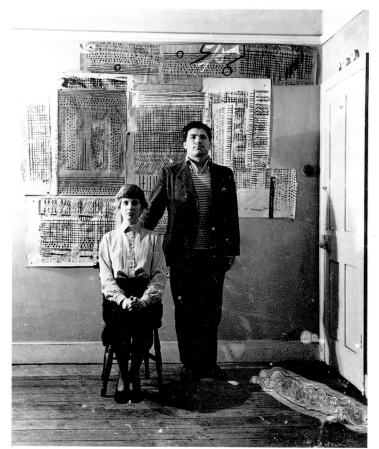

26

1952

Member of the Independent Group which met at the Institute of Contemporary Arts where he gave a 'lecture' called *Bunk* consisting of a series of disparate images drawn from pulp literature, magazines, technical books etc. projected from an epidiascope. Explored proto-pop themes with Toni del Renzio, Reyner Banham and Lawrence Alloway. Commissioned through Ove Arup and Alison and Peter Smithson to design ceiling decoration for the offices of R. S. Jenkins, 8 Fitzroy Street, London. Represented in the British Pavilion at the Venice Biennale in a ground-breaking show of young contemporaries. Visited Italy with Nigel Henderson. Entertained by Peggy Guggenheim in Venice, travelled to Naples and then to Viticuso where he visited relatives.

[26] Freda and Eduardo
Paolozzi in front of textile
designs, photographed by
Nigel Henderson 1951

[27] Paolozzi c.1950

[28] Mr Cruikshank 1950
Bronze
Presented by the artist 1998

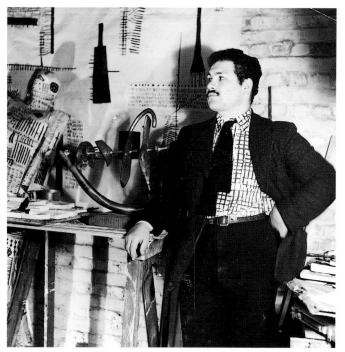

27

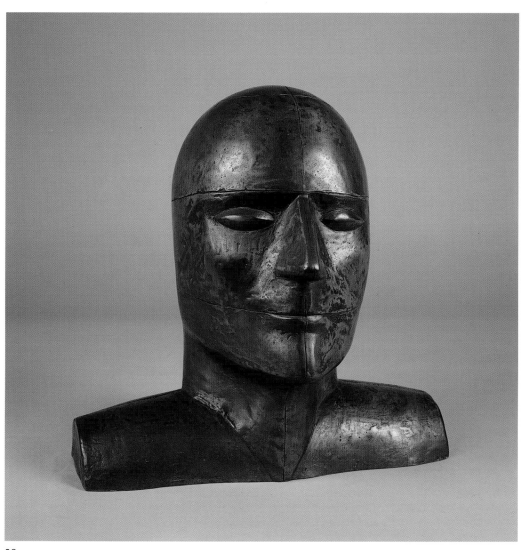

28

The Independent Group

In the winter of 1952 Paolozzi became a founder member of the Independent Group, together with Peter Reyner Banham, Theo Crosby, Richard Lanoi, Toni del Renzio, Sam Stevens, William Turnbull, Colin St John Wilson, Nigel Henderson, Ronald Jenkins and Edward Wright. This was an unofficial discussion group that met at the Institute of Contemporary Arts in London, which had itself been founded in 1948 by Roland Penrose and Herbert Read. These men had established their reputations before the war as spokesmen for modern art. The ICA was a sort of club for the promotion of young contemporary art, a base for discussion and innovation. In contrast to Read and Penrose the Independent Group members were formed by their experiences in the War. They were an anti-elitist, anti-academic group of artists, architects and thinkers who wanted to look at the effects of change in the modern world in a way that consciously and positively included mass culture.[22] The key texts for this group were Amédée Ozenfant's *Foundations of Modern Art*, D'Arcy Wentworth Thompson's *On Growth and Form* and Siegfried Giedion's *Mechanization Takes Command*.

Topics discussed by the Independent Group were very broad-ranging and included science fiction, action painting, cybernetics, western films, helicopters, popular music and car design. The first event was an epidiascope projection by Paolozzi of his Bunk collages and tearsheets. These consisted of images drawn from popular culture and pulp magazines. There was no commentary, just a rapid showing of disparate images that has since become recognised as an event of crucial importance for the development of Pop Art in England. The programme during the winter of 1952–3 had a technological theme. In 1953–4 Lawrence Alloway, John McHale, Magda and Frank Cordell, Richard Hamilton and Alison and Peter Smithson joined the Independent Group. In the winter of 1954-5 there was a proper discussion of popular culture.

In 1953 Independent Group members Nigel Henderson, Ronald Jenkins, Paolozzi and Alison and Peter Smithson put together an exhibition called Parallel of Life and Art at the ICA. Paolozzi and Henderson contributed photographs of machines, natural forms, paintings and drawings to illustrate

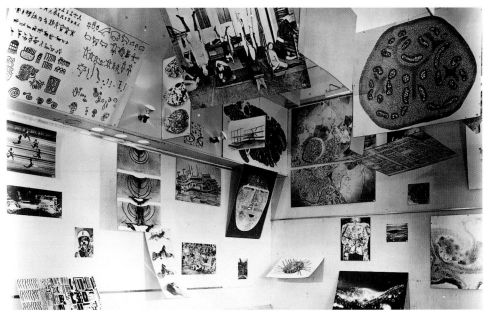

29

1953

Organised the exhibition *Parallel of Life and Art* at ICA with Nigel Henderson, Ronald Jenkins, Alison and Peter Smithson. National finalist in competition for *Monument to the Unknown Political Prisoner* sponsored by the ICA. Visited Hamburg in order to make a series of fountains for

an international horticultural exhibition. Purchased Gull Cottage, Landermere, Thorpe-le-Soken from Nigel Henderson.

1953–9

Made figurative sculpture, modelled in clay and cast by lost wax process, in Hampstead home of

Dorothy Morland, Director of ICA, aided by her son Francis.

1954

Exhibited three drawings at Venice Biennale. Hammer Prints company set up with Nigel and Judith Henderson to make textiles, ceramics and prints. Com-

pany lasted until 1964. Birth of first daughter Louise Carmela.

1955

Took up post teaching sculpture at St Martin's School of Art until 1958. Death of mother in Edinburgh. 4 May–4 June, exhibition of work in progress at ICA.

the underlying unity of art and life. (At this time they were both conducting technical and artistic experiments with photography.) The installation was innovative and environmental with photographic panels suspended from the ceiling as well as covering the walls [29]. The kaleidoscope of visual information was a three-dimensional rendering of the sort of mixture presented by Paolozzi in his *Bunk* 'lecture'.

Paolozzi's first major foreign commission came in 1953 when he was invited to make a series of fountains for an international horticultural exhibition in Hamburg. They consisted of tubular metal tower structures supporting metal troughs, which were suspended at various intervals but parallel to the overall rectilinear framework. It was a more formal development of the fountain that he had made for the Festival of Britain.

In 1954 the Paolozzis moved to Thorpe-le-Soken, near Colchester, after the birth of Louise, their first child. They purchased a cottage from Henderson who had inherited some property in the village. Paolozzi began to commute to London, spending weekdays as a lodger with Dorothy Morland, Director of the ICA, and going home at weekends to his family. In 1956 Henderson and Paolozzi once again worked together with Alison and Peter Smithson, this time on one of the twelve sections of the exhibition *This is Tomorrow* at the Whitechapel Art Gallery [30]. Their installation was called 'Patio and Pavilion' [31]. The patio had a sandy floor incorporating a Henderson photocollage with impressed clay tiles, bricks, stones and plaster sculptures around the perimeter. Inside the pavilion was a photocollage of a man's head by Henderson and a variety of 'archaeological items', plaster animals and Paolozzi's 1952 sculpture, *Contemplative Object*. The pavilion was a loose copy of huts in people's backyards. The transparent roof supported plaster reliefs, a drawing of a scorpion and *objets trouvés*. The group sought to create a personal view of human existence, with the patio representing a piece of the world and the pavilion an open room. Paolozzi with hindsight later said the installation was more Arte Povera than Pop Art. He was thereby disassociating himself from Pop and keying his work into the wider European scene.

[29] Installation photograph of *Parallel of Life and Art* 1953

[30] Peter Smithson, Paolozzi, Alison Smithson and Nigel Henderson, photographed for the catalogue of *This is Tomorrow* 1956

[31] *Patio and Pavilion* diagram for *This is Tomorrow* 1956

30

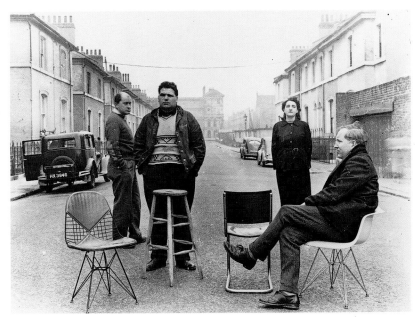

31

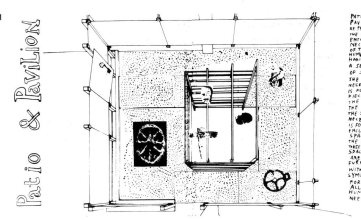

A New Style of Sculpture

In 1955 Paolozzi took up a post teaching sculpture at St Martin's School of Art. During the next three years he developed a new style of sculpture that consisted of encrusted reliefs collaged together. He made these reliefs by pressing a variety of found objects into clay and then pouring wax into the indented surface [32]. In the periodical *Uppercase*,[23] Paolozzi listed the kind of objects used in this process: '... dismembered lock, toy frog, rubber dragon, toy camera, clock parts, broken comb, parts of a radio, an old RAF bomb sight, natural objects such as pieces of bark, gramophone parts and model cars.' Paolozzi also said that 'the use of *objets trouvés* as the raw materials of sculpture makes it possible to suggest a kind of spontaneity that is of the same nature as that of much modern painting, even if, in my case, this spontaneity turns out to be, after all, an illusion.'[24] This sort of *bricolage* was partly influenced by his earlier exposure to Dubuffet in Paris and to the French artist's recent exhibition at the ICA, and also by a show of Picasso at the Marlborough Gallery which had included *Assemblage Baboon with Baby* 1951. One cannot overemphasise the importance of Dubuffet and *art brut* for the development of Paolozzi's series of rough-textured, blasted sculptures. The naive simplicity of the collaged forms of bodies and animals was in opposition to the more formalist approach taken in the teaching of sculpture at St Martin's.[25] However, he did have kindred spirits in his colleagues Elizabeth Frink and Anthony Caro: Frink with her expressive brutalist animals and Caro with his (at this time) roughly textured monumental human forms.

Paolozzi became obsessed with the transformation of objects through a series of interventions into a new entity. He explored this metamorphosis through various working stages and described them as follows: 'I first build up my model by cementing my salvaged *objets trouvés* together with clay, after which I make, with my assistant, a plaster cast of them, and in this cast a wax mould that is finally sent to be cast in bronze. This is what imposes, in addition to a formal metamorphosis, a material metamorphosis on all my materials. In the finished casting the original *objets trouvés* are no longer present at all, as they are in the Dada and Surrealist compositions of this kind. They survive in my sculptures as ghosts of forms that still haunt the bronze, details of its surface or its actual structure.'[26] An early statement of Paolozzzi's underlines his visionary ambition: 'I suppose I am interested, above all, in investigating the golden ability of the artist to achieve a metamorphosis of quite ordinary things into something wonderful and extraordinary that is neither nonsensical nor morally edifying.'[27]

From his period in Paris Paolozzi discovered an interest in 'Klee's allusive microcosms, in Raymond Roussel's use of ready-made phrases and in the

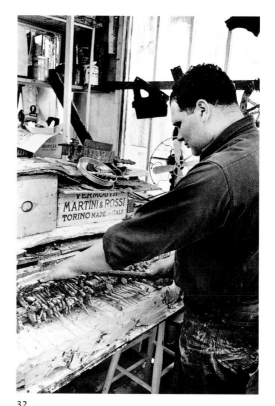

32

[32] Paolozzi at Thorpe-le-Soken pressing found objects into a bed of clay

[33] *Krokadeel* c.1956–9
Bronze
Purchased from Gabrielle Keiller 1987

1955–6
Included in *Young British Sculptors*, Arts Club of Chicago and tour of USA and Canada organised by British Council.

1956
On advice of Erica Brausen of Hanover Gallery took waxes to Paris to be cast by Susse Frères.

At this period used found objects which he pressed into clay beds which were then cast in bronze using the lost wax method. Together with Nigel Henderson and Alison and Peter Smithson created one of twelve installations for the exhibition *This is Tomorrow* at the Whitechapel Art Gallery, London. Noma and William Copley Foundation award. Acted with Michael Andrews in low budget art film *Together* by Lorenza Mazzetti (an ex-Slade student) playing a deaf mute.

1957
Daughter Anna Francesca born. Joint exhibition with Nigel Henderson at Arts Council Gallery in Cambridge.

1958
Included in *Seven Sculptors* exhibition at Solomon R. Guggenheim Museum, New York. On 30 April, gave illustrated lecture at ICA (including images of crashed cars) in which he explained his artistic process as the 'metamorphosis of rubbish'. 11 November–31 December, one-man show at Hanover Gallery. Photo experiments with Nigel Henderson.

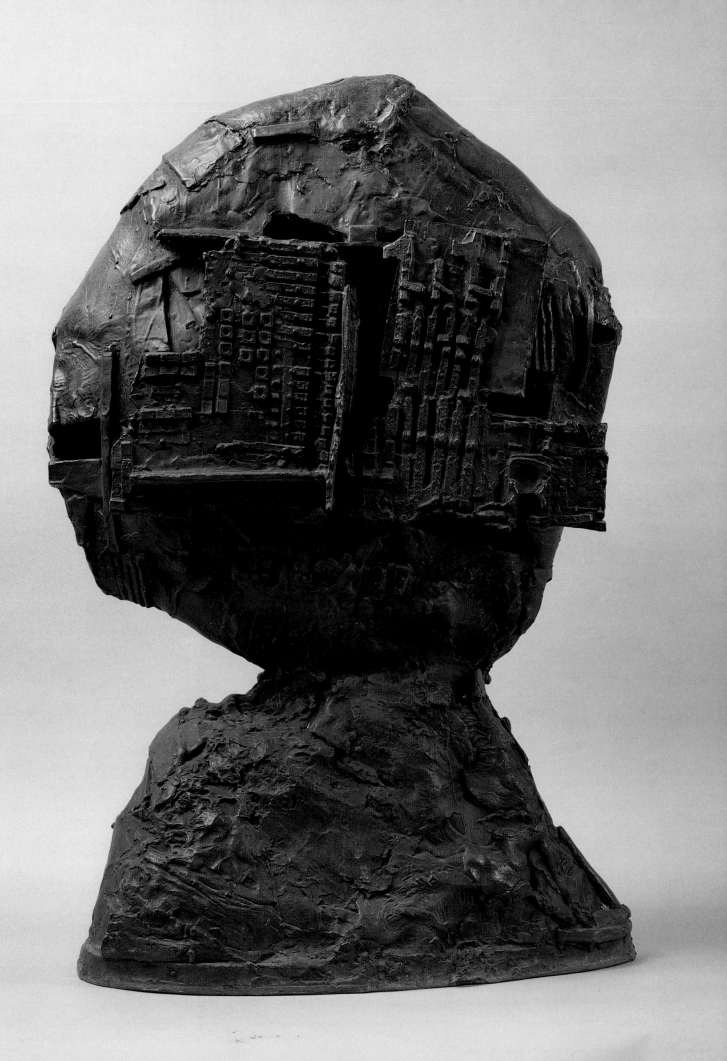

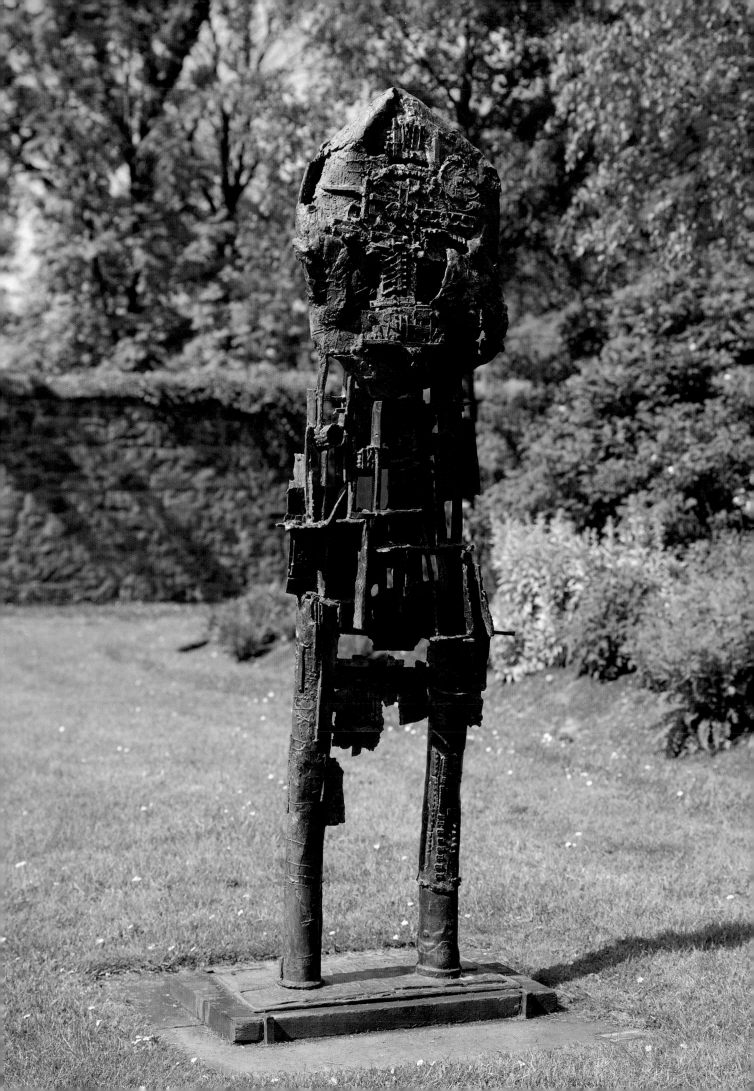

primitivism of Dubuffet's human diagrams.'[28] The richly encrusted works of the late 1950s such as *Krokadeel c.*1956–9 [33], *St Sebastian I* 1957 [34] and *Large Frog (New Version)* 1958 [35] all bear witness to this fascination with the metamorphosis of detritus, with the raw untutored art of *art brut*. In 1958 he called these works 'A bronze framework containing symbols resembling bent mechanisms ... WORLD WITHIN A WORLD. A LANDSCAPE WITHIN A FACE ... My preoccupation or obsession is with the metamorphosis of the figure' [36, 37 and 38].[29]

An important influence at that time was Francis Bacon whom Paolozzi met at the Colony Club and elsewhere. Paolozzi was moved by Bacon's distorted vision of humanity–what Diane Kirkpatrick has called the 'damaged man' theme,[30] common also to the sculpture of Germaine Richier and the paintings of Willem de Kooning.

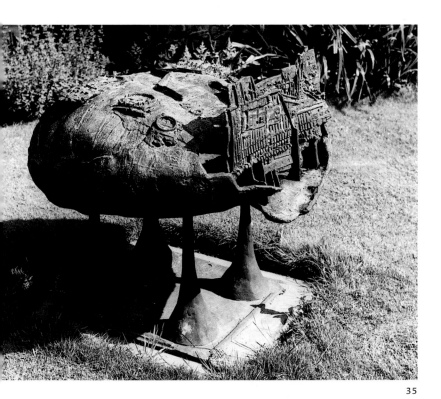

35

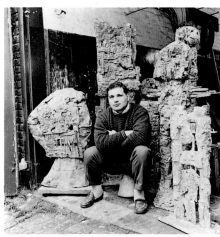

36

38

Left [34] St Sebastian I 1957
Bronze
Purchased from Gabrielle Keiller 1993

[35] Large Frog (New Version) 1958
Bronze
Purchased from Gabrielle Keiller 1993

[36] Paolozzi with sculptures (left Head, right Icarus I)

[37] Icarus I 1957
Bronze
Presented by the artist and Lund Humphries in memory of the late E.C. Gregory 1962

[38] Icarus II 1957
Bronze
Purchased from Gabrielle Keiller 1993

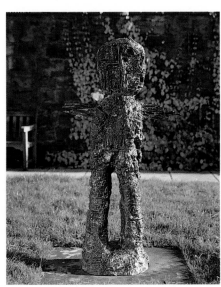

37

Machine Idols

In the late 1950s Paolozzi began to use machine imagery in a new way in his sculptures. In 1958 he made the totemic piece, *His Majesty the Wheel* [39], which incorporated machine elements as facial features and body parts. This interest in mechanical forms led him, two years later, when he spent two years at the Hamburg Hochschule für bildende Künste, to explore the shipbreakers' yards [40]. There he found a rich new vocabulary of mechanical, prefabricated shapes. These ideas on machine shapes resulted in *Tyrannical Tower Crowned with Thorns of Violence* 1961 [41], another totemic figure made up of rectangular plates, grids and finials. It was this discovery of prefabricated, engineered parts that led to Paolozzi's subsequent collaborations with Jim Thackeray and Juby's engineering works in Ipswich [42].

In 1962 Paolozzi wrote: '... a wheel, a jet engine, a bit of machine is beautiful, if one chooses to see it that way. It's even more beautiful if you can prove it, by incorporating it in your iconography. For instance, something like the jet engine is an exciting image if you're a sculptor.'[31] He went on to make a series of what have been called machine idols, using found objects and cast elements. These abstract constructions with no specific connotations marked a real break in Paolozzi's work. Such pieces as *The Bishop of Kuban* 1962 [43], *Wittgenstein at Casino I* 1963 and *Solo* 1962 are monumental, witty and inventive compositions using aluminium prefabricated parts.

In a similar vein Paolozzi made *Four Towers* 1962 [44], *Chord* 1964 [45] and *Domino* 1967–8 [46], all in the Scottish National Gallery of Modern Art's collection. The first two were painted and the last was highly polished. The most complex work of this period, *Hamlet in a Japanese Manner* 1966 [47], has, over the years, been painted four times with psychedelic patterns and vivid colours – the first three times to explore different configurations, after which it was stripped. The final repainting is a reconstruction of the first version. Diane Kirkpatrick suggests that the early painted work, *Karakas* 1964, was influenced by David Smith's and Anthony Caro's experiments with painted sculpture.[32] However,

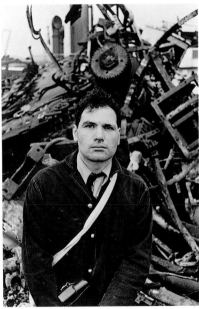

40 42

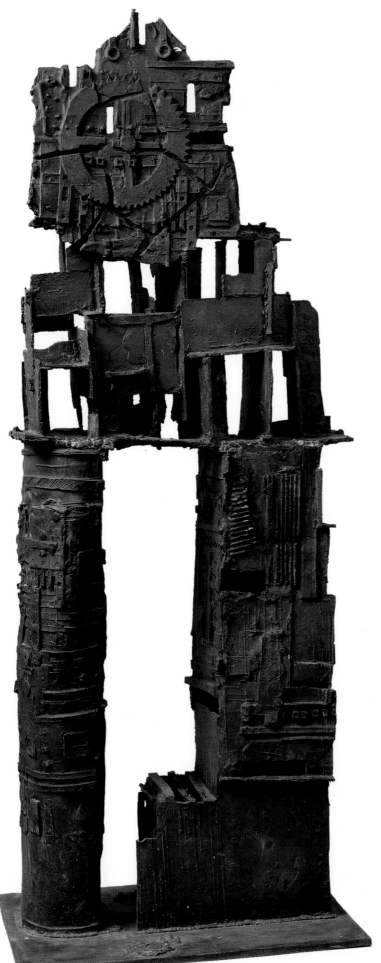

39

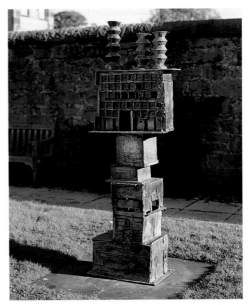

41

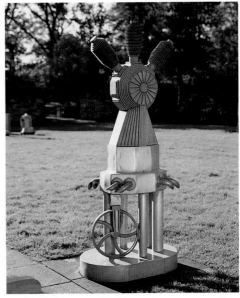

43

[39] *His Majesty the Wheel* 1958
Bronze
Purchased from Gabrielle Keiller 1993

[40] **Paolozzi in shipbreaker's
yard in Hamburg** 1961

[41] *Tyrannical Tower Crowned with
Thorns of Violence* 1961
Bronze
Purchased from Gabrielle Keiller 1993

[42] **Paolozzi at Juby's engineer-
ing works, Ipswich** c.1973–4

[43] *The Bishop of Kuban* 1962
Bronze
Purchased from Gabrielle Keiller 1990

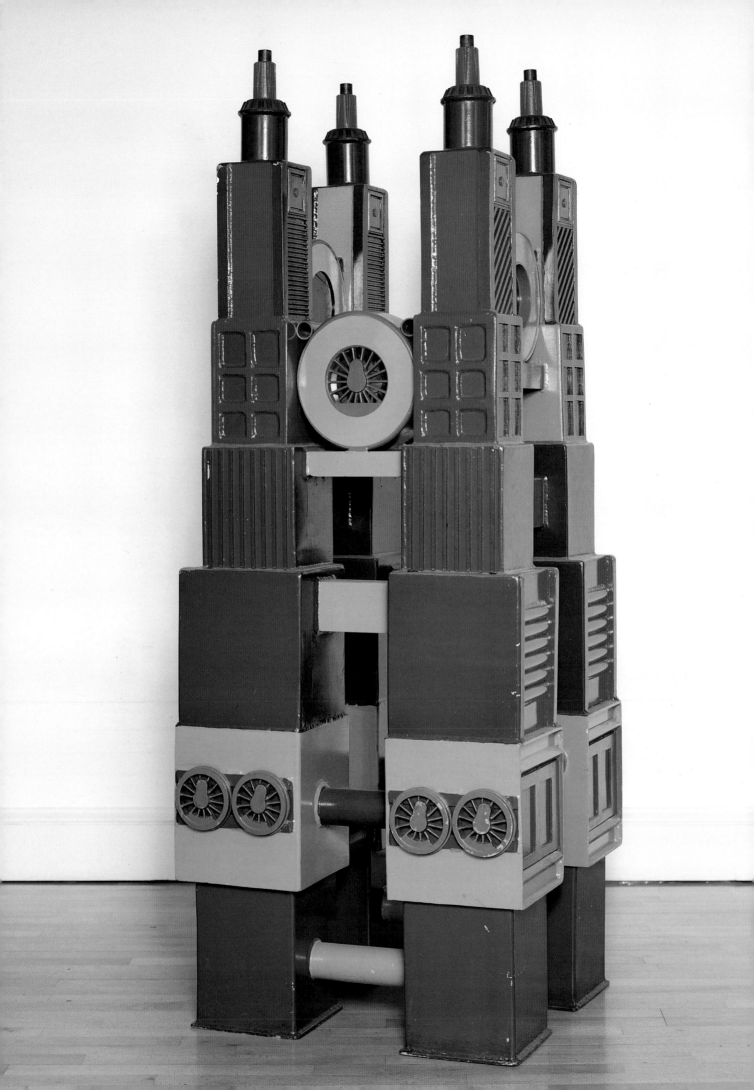

Paolozzi differed from these sculptors in his use of a complex pattern working both with and against prefabricated shapes.

Paolozzi also worked with highly reflective surfaces, using polished and chromed steel. In 1964 he introduced a new element into his sculpture, a curved, contour shape. The final development of these curved, polished forms was the monumental *Osaka Steel* 1969 made for Osaka in Japan [48]. It is possible to compare these abstract works with the spare primary structures of his American contemporaries Donald Judd and Robert Morris. However, whereas the Minimalists created compositions which evoke no associations or meanings, Paolozzi created works that are multi-evocative.[33]

By the end of 1960 Paolozzi was established as a sculptor of note. In 1959 he had been included in the *New Images of Man* exhibition at the Museum of Modern Art in New York and in *Documenta II* at Kassel in Germany. In 1960 he was featured once more in the British Pavilion at the Venice Biennale and works were bought by the Guggenheim and the Museum of Modern Art in New York. It was at Venice that Paolozzi met Gabrielle Keiller who was to become his major patron over the next decade and a half. Her subsequent friendship with Paolozzi led to the formation of a superb collection of Dada and Surealist art and literature. Also in 1960 Paolozzi was given the Award for the Best Sculptor under 45 by the David E. Bright Foundation at Venice and had a one-man show at the Betty Parsons Gallery in New York. In 1963 Michael Middleton wrote a small book about him. Middleton was very perceptive and hailed Paolozzi as a free spirit, relaxed, spontaneous and uncontaminated.[34] In the seminal 1965 book, *Private View*, Paolozzi's work was likened by Bryan Robertson and John Russell to that of Giacometti, Matta and Noguchi.[35]

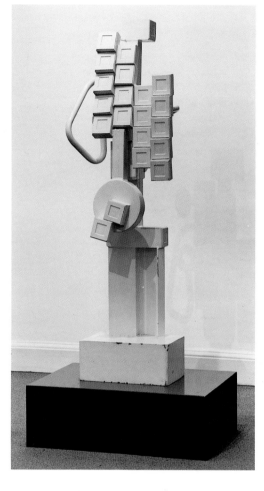

[44] *Four Towers* 1962
Painted aluminium
Presented by the artist 1966

[45] *Chord* 1964
Painted aluminium
Purchased from Gabrielle Keiller
1993

45

which gave him some castings which he took back to England, re-cast and incorporated into works. Began working on totemic machine idols such as *Diana as an Engine*. Experimented with woodcuts using ordinary carpentry tools.

1961
Joint exhibition in Paris and Oslo with Victor Pasmore. Watson F. Blair Prize at 64th Annual American Exhibition, Chicago.

1962
23 April–12 May, one-man show at Betty Parsons Gallery, New York. Published book, *Metafisikal Translations*, with Kelpra Studio, London. *British Art Today* exhibition toured America.

1963
5–28 September, one-man show, *Paolozzi: New Works*, at Waddington Galleries, London.

Published book, *Metallization of a Dream* (text by Lawrence Alloway) with Lion and Unicorn Press, Royal College of Art, London and a screenprint of the same title. Also published print, *Conjectures to Identity* 1963–4, printed by Kelpra Studio.

[46] *Domino 1967–8*
Aluminium
Presented by Gabrielle Keiller 1984

overleaf [47] *Hamlet in a Japanese Manner 1966*
Painted aluminium (second state of painting)
Glasgow Art Galleries and Museum

[48] *Study for 'Osaka Steel' 1969*
Polished bronze
Bequeathed by Gabrielle Keiller 1995

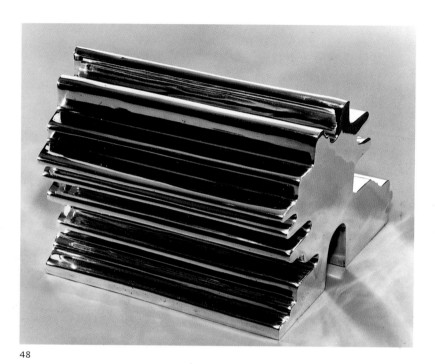

48

46

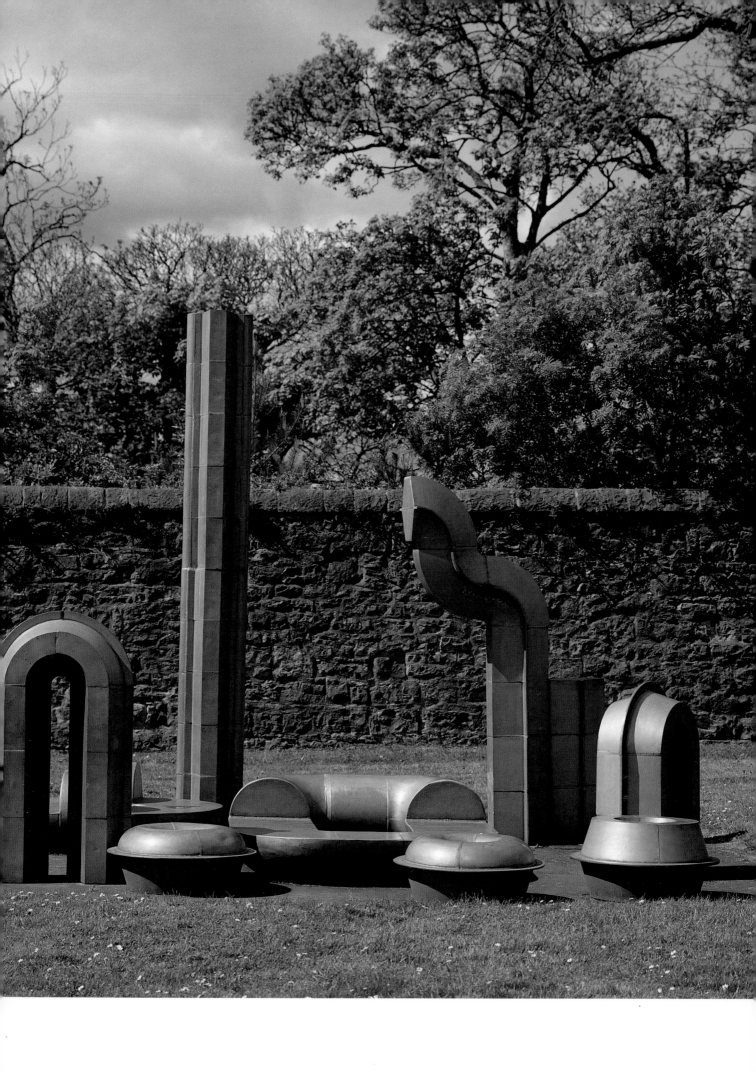

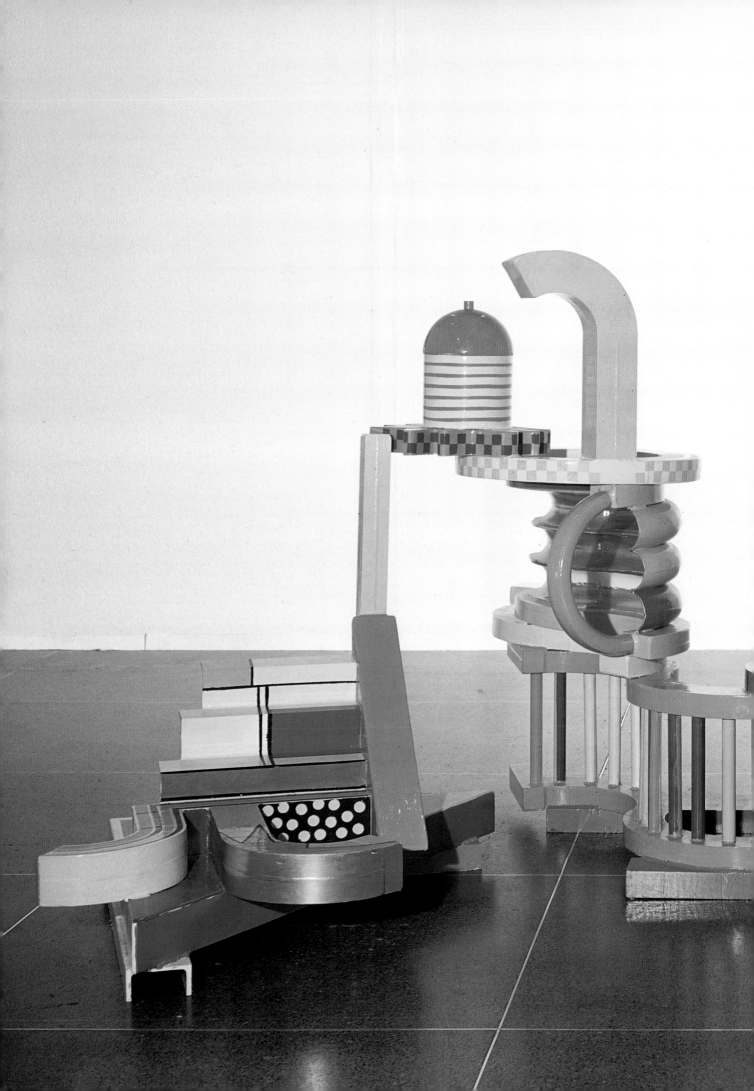

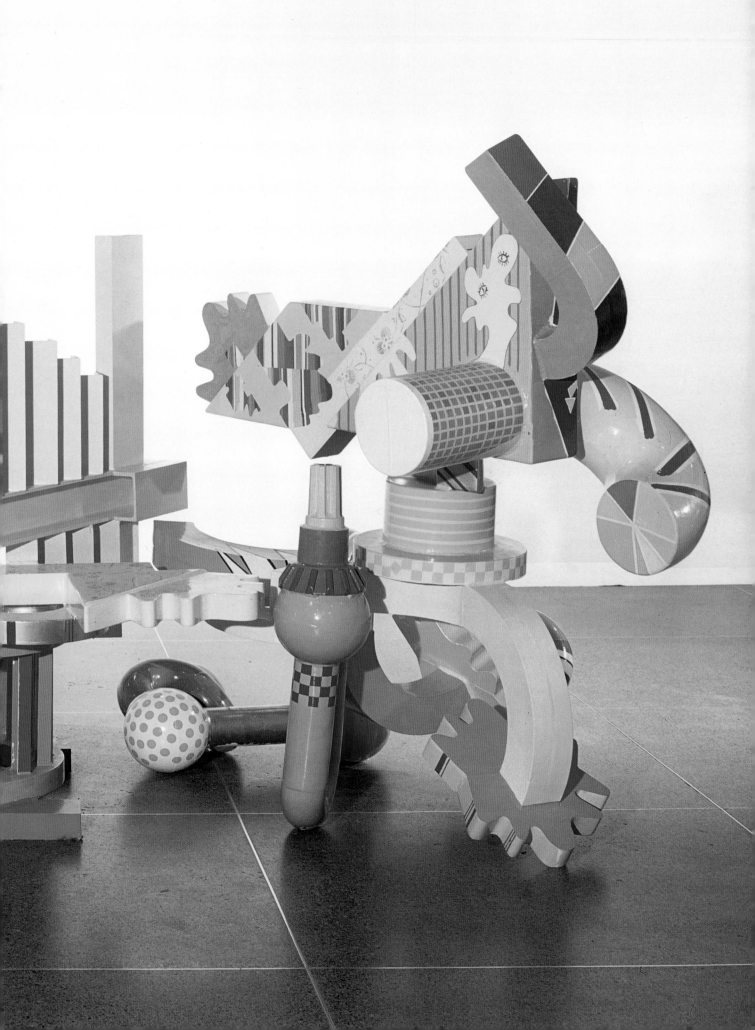

Printmaking

Paolozzi became extremely active in the field of printmaking during the 1960s.[36] In 1962 he began a successful collaboration with Chris Prater at the Kelpra Studios with the screenprint *Metallization of a Dream* [49] based on a collage that he had made in Germany during the production of collages for the film, *The History of Nothing*. A second version was published in 1963 in an edition of 40 with each pull having a unique colour combination. This novel use of colour combinations, published four years before Warhol's serially coloured prints of Marilyn Monroe, was explored to the full in Paolozzi's important series of screenprints inspired by the life of Ludwig Wittgenstein, *As Is When* 1965 [50]. The prints include images of skyscrapers, diagrammatic dummy heads and aeroplanes all of which appeared in Paolozzi's work over the next two decades. The naturalistic elements are interspersed with blocks of pattern and text. This was a new departure in Paolozzi's work. The approach was repeated in his later print series, *Moonstrips Empire News* 1967 [51], *General Dynamic F.U.N.* 1965–70 [52], *Universal Electronic Vacuum* 1967 and *Zero Energy Experimental Pile (Z.E.E.P.)* 1970 [53]. The imagery here is very diverse: for example, Walt Disney cartoon characters, works by Michelangelo, advertisements, fashion pictures, war documentation, film stills and illustrated juke box lists. Although many of these depict modern life they are also critiques of reality. Paolozzi later said that despite the closeness of his work to Pop Art, he didn't want to go down in history as a Pop artist whom he saw as accepting modern life basically as it was. He said he would much rather be seen as an observer of something which gave a hint of deeper European roots.[37]

In 1969 Paolozzi was in California as part of an art and technology programme and as a visiting Professor at Berkeley, where he had a print retrospective.

While there he visited Hollywood, automobile plants, waxwork museums and specialist fashion shops. He also went to aerospace and road safety centres. In the latter Paolozzi saw dummies used for crash experiments, an experience repeated in the same year in Japan. This subject matter inspired his print series *Conditional Probability Machine* of 1970 [54] in which he moved from screenprints to photo-etching in order to simulate photojournalism. Another photo-etching suite made the following year was called *Cloud Atomic Laboratory* [55]. This consisted of air-brushed images based on photographs. Real events are mixed with fantastic images and there is an element of humour in the pictures of children playing with science-fiction-based toys. Paolozzi has spoken of seeing all kinds of ironies in his material.[38]

Paolozzi had one-man shows during the 1960s in New York, London, Newcastle, Edinburgh, Otterlo, Amsterdam, Düsseldorf and Berlin. He published several artists' books with Surrealist-inspired collage texts: *Metafisikal Translations* 1962, *The Metallization of a Dream* 1963, *Kex* 1966 and *Abba Zabba* 1970. In 1968 he took up a teaching post in the Ceramics Department of the Royal College of Art in London, a post that led to a Visiting Professorship upon his 'retiral' in 1989.

[49] *Metallization of a Dream*
1963
Screenprint on paper
Bequeathed by Gabrielle Keiller 1995

1964

Eduardo Paolozzi Sculpture, Museum of Modern Art, New York. *Eduardo Paolozzi: Recent Sculpture and Collage*, Robert Fraser Gallery, London. *As Is When*, first major series of screenprints based on the life of Wittgenstein. Began *Hamlet in a Japanese Manner*, large painted sculpture. Made sculptures and collage prints in tandem, e.g., *Parrot*.

1964–9

Polished chrome and bronze abstract sculptures such as *Trio* and *Kimo*, small enough for domestic interiors.

1965

Film *Kakafon Kakkoon* (animation: Peter Leake and Keith Griffiths). *Eduardo Paolozzi: Recent Sculpture, Drawings and Collages*, Hatton Gallery, The University of Newcastle-upon-Tyne.

1966

Published book, *Kex*, edited by Richard Hamilton, for the William and Noma Copley Foundation. Completed *Hamlet in a Japanese Manner*. Exhibitions at the Pace Gallery, New York, Robert Fraser Gallery, London, and the Scottish National Gallery of Modern Art.

1967

Purchase Prize, *Carnegie International Exhibition of Contemporary Painting and Sculpture*, Pittsburgh. Screenprint portfolios, *Moonstrips Empire News* and *Universal Electronic Vacuum* (folio of ten screenprints) both printed by Kelpra. Purchase Prize at *International Sculpture Exhibition*,

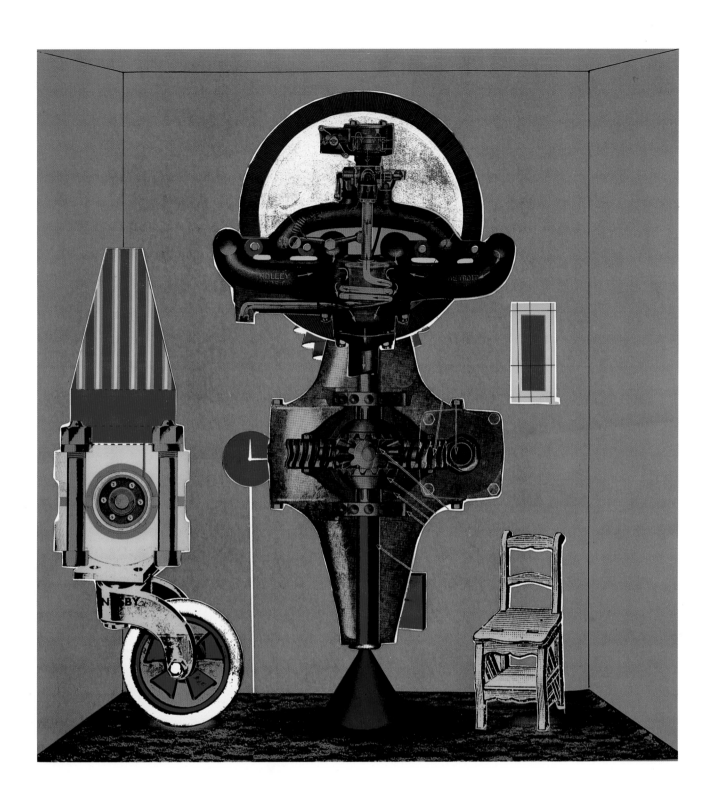

Solomon R. Guggenheim Museum, New York. Exhibitions at the Rijksmuseum Kröller-Müller, Otterlo and the Hanover Gallery, London.

1968
Awarded C.B.E. Visiting Professor at the University of California, Berkeley, where he had a print retrospective. Took up post teaching ceramics at Royal College of Art. Tapestry for the Whitworth Art Gallery, University of Manchester. Exhibition of silkscreen prints at the Stedelijk Museum, Amsterdam.

1968–9
Exhibitions in Düsseldorf and Stuttgart.

1969
Made monumental sculpture, *Osaka Steel*, for Expo Osaka and lived in Japan. Included in *Pop Art Redefined*, Hayward Gallery, London. Exhibitions in Göteborg and Berlin. Organised exhibition of american graphics at Royal College of Art, including bubble gum stickers. Researched computer graphics display system for an exhibition.

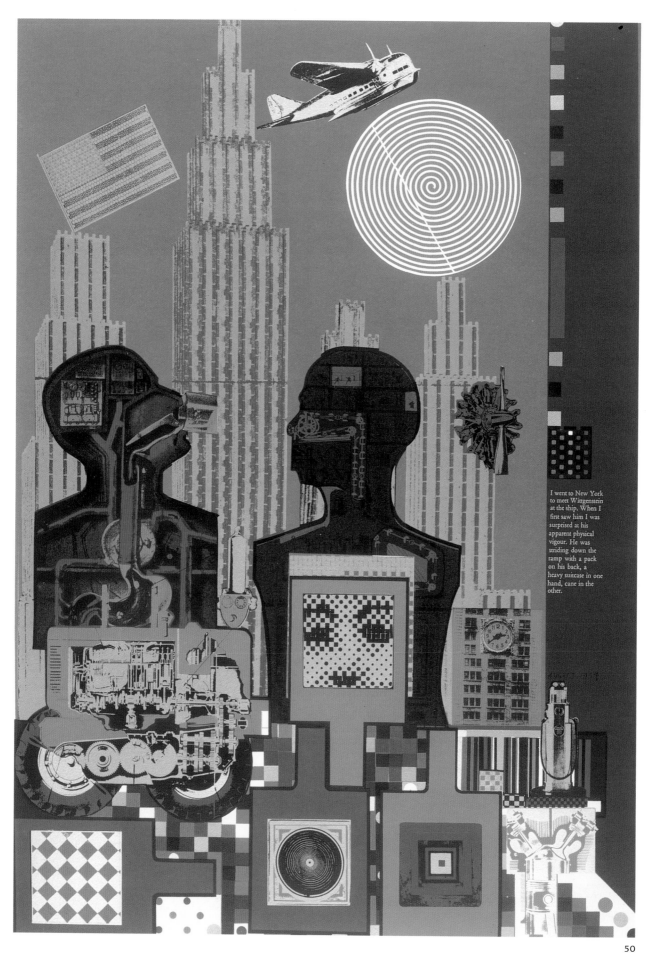

I went to New York
to meet Wittgenstein
at the ship. When I
first saw him I was
surprised at his
apparent physical
vigour. He was
striding down the
ramp with a pack
on his back, a
heavy suitcase in one
hand, cane in the
other.

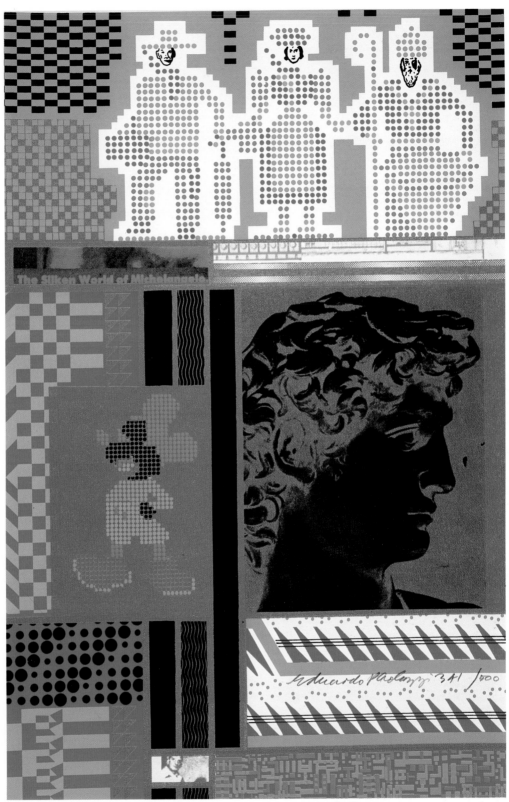

[50] *Wittgenstein in New York*
from As is When 1965
Screenprint on paper
Courtesy of the Trustees of the Tate
Gallery, London

[51] *Silken World of Michelangelo*
from Moonstrips Empire News
1967
Screenprint on paper

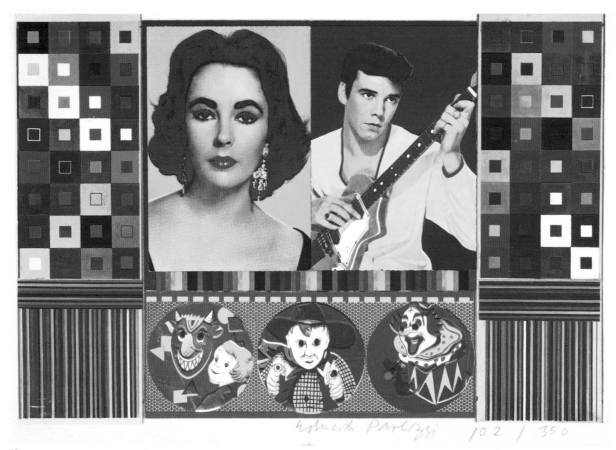

Eduardo Paolozzi 102 / 350

52

54

55

[52] *An Empire of Silly Statistics from General Dynamic F.U.N.* 1965–70
Screenprint on paper
Presented by the artist 1998

[53] *Hollywood Wax Museum from Zero Energy Experimental Pile (Z.E.E.P.)* 1969–70
Screenprint on paper
Presented by the artist 1998

[54] *Photogravure from Conditional Probability Machine* 1970
Presented by the artist 1998

[55] *Photogravure from Cloud Atomic Laboratory* 1971
Presented by Gabrielle Keiller 1980

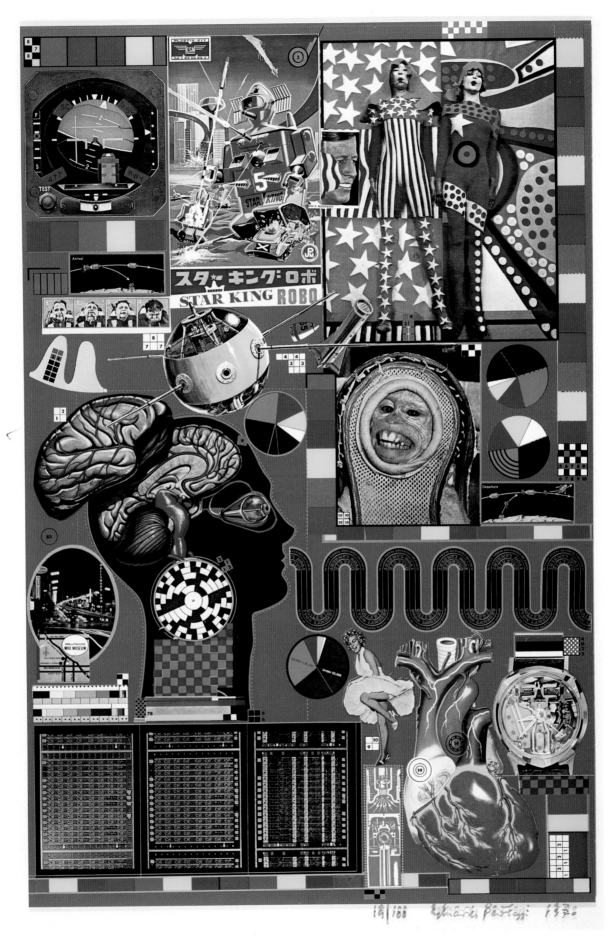

53

The Tate Gallery Retrospective

Paolozzi's public exposure culminated in 1971 in a large retrospective at the Tate Gallery [56]. For this exhibition he cast a number of 'readymades' such as *Crash Head* (a plastic educational toy) [57] and *Tim's Boot* (an enlarged Vietnam serviceman's boot) [58]. He continued the war theme with a number of bomb sculptures. Paolozzi remembers being on an anti-Vietnam march in New York at that time: 'I seemed to be the only one that seemed to be involved in one's art in Vietnam, the war in Vietnam. I mean the cover of the catalogue was a boot and there was a group of bombs that had something to do with napalm.'[39] The poster of the Tate show showed an FBI shooting target of a man. This dehumanisation of man, or man as an expendable object, was one of the themes of the Tate exhibition. (Paolozzi had already explored the animal rights theme in his *Conditional Probability Machine* prints.) The exhibition also contained spoofs on contemporary art, a *Kitsch-Kabinet* [59] and a large installation of a skip full of offcuts of old sculptures. The 1971 screenprint B.A.S.H. featured J. F. Kennedy along with Marilyn Monroe [60] and was offered in a large edition to readers of *The Observer* newspaper, to mark the exhibition. Two strands of thought were discernable within the show: Paolozzi's background in Surrealism and the influence of the later work of Marshall McLuhan, guru of the mass-media. This kaleidoscopic view of contemporary life had been explored by Paolozzi in his films, *The History of Nothing* 1960–2, *Kakafon Kakkoon* 1965 and *Mr. Machine* 1971.

Paolozzi's use of multifarious images drawn from contemporary life can be traced back to his *Bunk* 'lecture' of 1952 and to his collages of the late 1940s. The publication in 1972 of a suite of prints called *Bunk* and drawn from the material of two decades before was a vindication of his youthful enthusiasm for popular culture [61]. But despite his role (through such works as *Bunk*) as a founding father of

the Pop Art movement in Britain, Paolozzi remembers that at the time of the Tate exhibition he felt that he had no peer group to support his work. It has been suggested that foreign artists such as Broodthaers, Warhol and Lichtenstein were in fact closer to his way of working.[40]

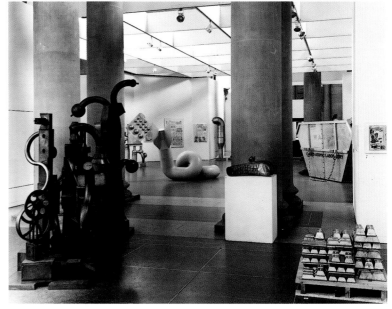

56

59

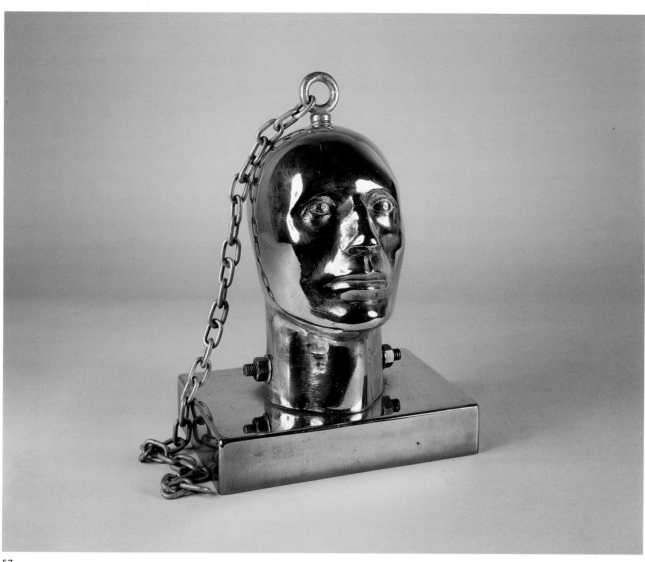

57

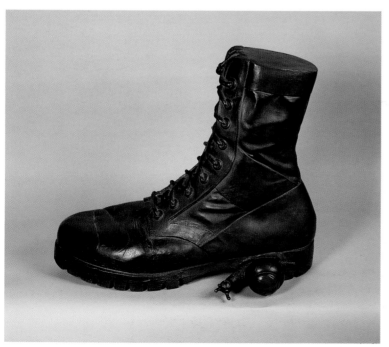

58

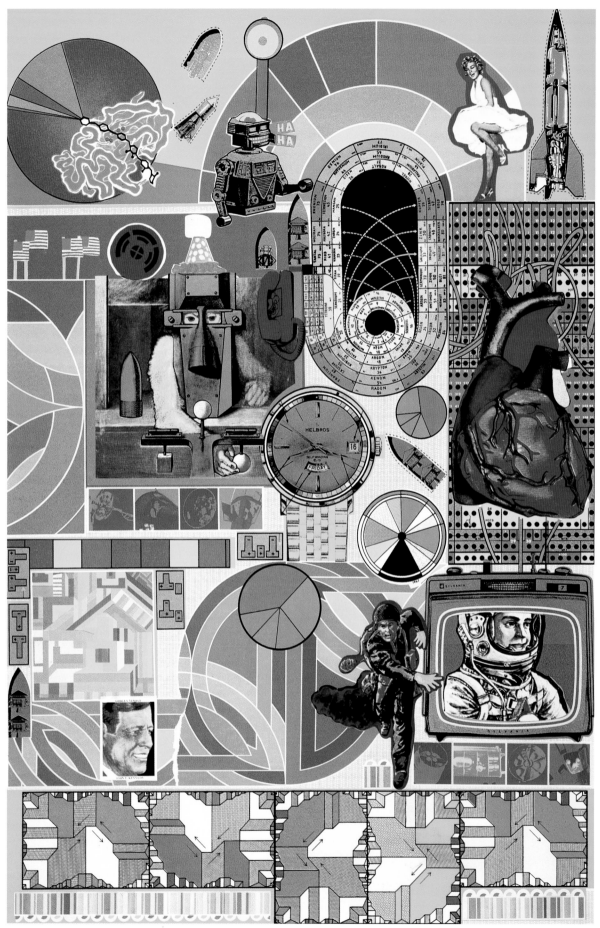

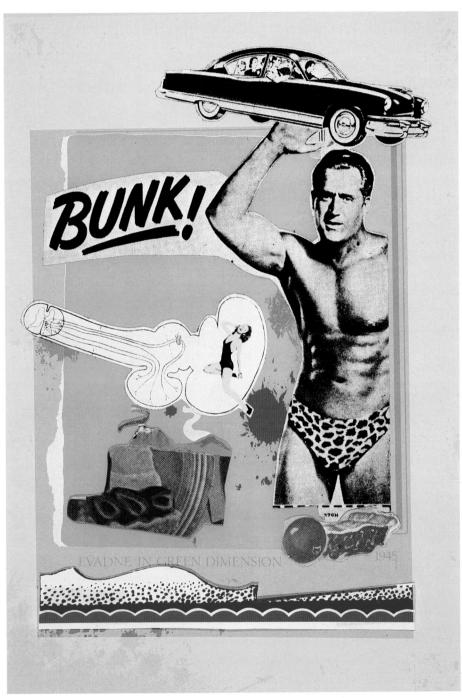

61

Abstract Reliefs and Printmaking

In 1970 Paolozzi reinvented himself once more, with a move to abstraction in printmaking and relief sculpture. He had discovered a German magazine illustration of 1927 rendering organ music in the form of a patterned composition. This became the basis for his new visual vocabulary. It was used in the prints *Kosmos* 1975 and *Mr Peanut* 1970 [62] and in studies for the ceiling reliefs and tapestries for Cleish Castle near Kinross in Fife 1972–3 [63]. The entire scheme was later removed from the castle and the ceiling has now been installed in the Dean Gallery, on long loan from the City of Edinburgh. The language of the Cleish panels, with their wavy contour reliefs and geometric patterns, was further developed in the 1975 relief, *Niigata Turkoma* [64]. Here the artist used a ribbed ground against which the chequerboard patterns and geometric shapes stand out in high relief. Paolozzi filled sketchbook after sketchbook at this time with drawings exploring such configurations. In 1976 he was commissioned to make a set of large aluminium doors for the Hunterian Art Gallery at the University of Glasgow [65]. For these he used the imagery he had invented for *Niigata Turkoma*. He later recalled how he collaged plaster elements onto boards for his first designs, just as he had cut and collaged elements for his prints.

In 1974 Paolozzi was invited to West Berlin for one year to work as a guest of the German Academic Exchange Service (DAAD). He was given the entire floor of a factory building in the Kottbusserdamm area of Kreuzberg [66]. Here he made a series of reliefs including *Kreuzberg* [67] and a suite of prints, *Calcium Light Night*, in homage to the American composer Charles Ives [68]. Paolozzi continued his links with Berlin in 1975 when he had retrospective exhibitions at the Nationalgalerie and the Kupferstichkabinett, which included his most recent suite of woodcuts, *For Charles Rennie Mackintosh* [69]. In 1976 he was commissioned to design a mural for Kurfürstenstrasse 87 in Berlin.

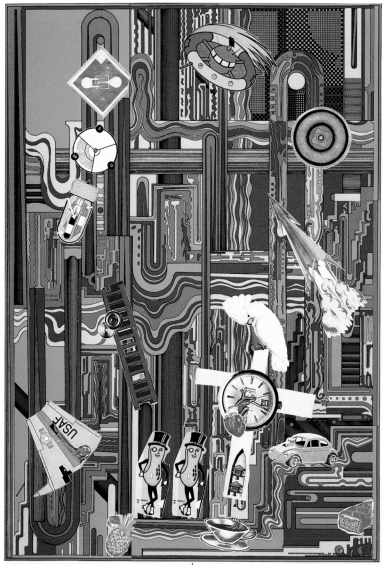

62

1972

Bunk box of 47 prints after collages of 1947–52. Became A.R.A. Exhibited in *British Sculptors*, Royal Academy of Arts, London. *Eduardo Paolozzi: The Conditional Probability Machine* at the St Katherine's Gallery, St Andrews. Began collaboration with Ray Watson, who executed relief maquettes for bronze, resin and wood. On 17 July attended lunch at 10 Downing Street for Ronald Reagan.

1972–3

Worked on commission for nine ceiling panels and three tapestries for Cleish Castle near Kinross in Scotland using abstract patterns drawn from *Kosmos* print. Tapestries woven by Edinburgh Tapestry Company and reliefs made in London.

1973

Sculpture playground for Terence Conran at Wallingford.

1974

Invited to work in Berlin by DAAD (German Academic Exchange Service) and given large space in disused factory. The *Ravel Suite* of six etchings. For *Gaudí*, children's playground in Tenerife commissioned by Colegio Oficial de Arquitectos de Canarias, architect Carlos Schwartz. *Kreuzberg* reliefs. Exhibition, *Heroes and Villains: A Study in Leadership from the Krazy Kat Arkive*, Department of Fine Art, University of St Andrews. Finished collaboration with Juby's.

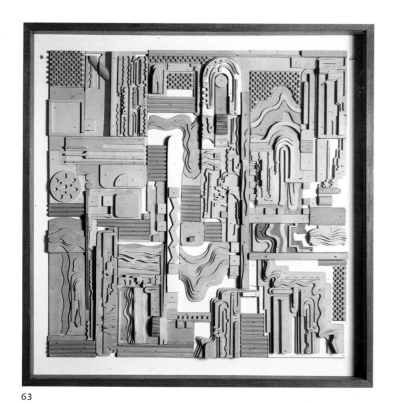

63

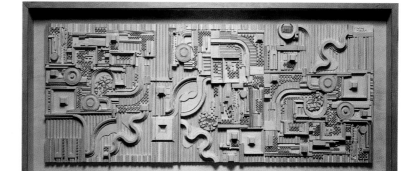

64

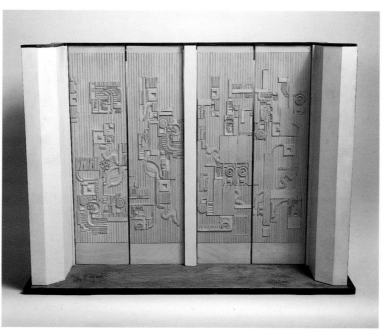

65

[66] Paolozzi in his Berlin
studio 1974

[67] *Kreuzberg* 1974
Bronze
Purchased from Gabrielle Keiller
1993

[68] *The Children's Hour* from
Calcium Light Night 1974–6
Screenprint on paper
Presented by the artist 1998

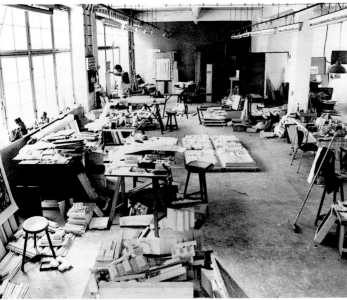

66

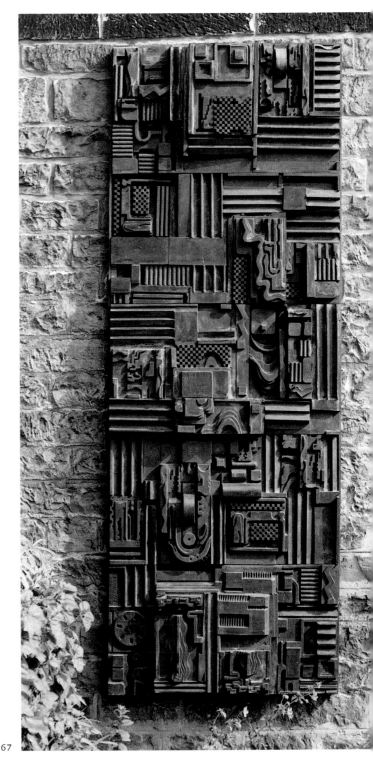

67

<table>
<tr><td>

1974–5
December–January, one-man
show at the Kestner-
Gesellschaft, Hanover.

1975
February–April, retrospective
exhibitions at Nationalgalerie
and Kupferstichkabinett in
Berlin. Marlborough Graphics

</td><td>

published *For Charles Rennie
Mackintosh*, a set of six wood-
cuts. Saltire Society Award for
Cleish Castle works. Exhibition
of works on paper at Kunsthalle,
Bremen.

</td><td>

1976
Completion of *Calcium Light
Night*, suite of nine screenprints
based on the work of the com-
poser Charles Ives. Mural for
Kurfürstenstrasse 87, Berlin.
One-man shows at Marlborough
Fine Art, London and
Fruitmarket Gallery, Edinburgh.

</td><td>

1976–7
Made doors for Hunterian Art
Gallery, University of Glasgow.
Arts Council touring exhibition
of sculpture and works on paper.

1977
Hommage to Anton Bruckner,
commissioned for the exhibition
Forum Metall at Linz, Austria. *The*

</td><td>

*Complete Prints of Eduardo
Paolozzi: Prints, Drawings, Collages
1944–77*, Victoria & Albert
Museum, London. Appointed
Professor of Ceramics,
Fachhochschule, Cologne.

</td></tr>
</table>

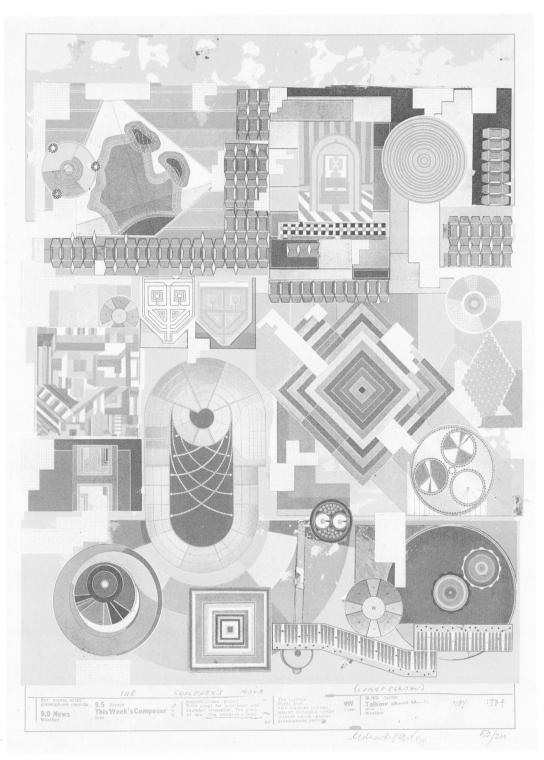

68

1978–82
Utopia, suite of etchings derived
from an aerial view of Frank
Lloyd Wright's Broad Acre City.

1979
Elected R.A. Awarded Honorary
Doctorate, Royal College of Art,
London. Relief for Lurriper-
strasse 1, Mönchengladbach,

commissioned by the town of
Mönchengladbach. Three
bronze reliefs for Moorweiden-
strasse 3, Hamburg. One-man
exhibitions at St Andrews, Edin-
burgh and Cologne.

1980
First prize in closed competition
for development of Rhein-
garten, Cologne. Hon. D.Litt.,
University of Glasgow; Hon.
R.S.A.; Deutsche Welle Mosaic,
Raderberggürtel 50, Cologne.

Public Commissions

During this period Paolozzi undertook a number of public commissions. He said in an interview with Richard Hamilton: 'I've been trying to get away from the idea, in sculpture, of making a thing–in a way, going beyond the Thing, and trying to make some kind of presence.'[41] His 1977 cast-iron sculpture, *Homage to Anton Bruckner*, for Linz in Austria [70], was a low rectangular composition made of concentric, serrated planes. It was set directly on grass to be part of the environment. Paolozzi made it his policy with his public projects of the next two decades that they should be interactive. Rainwater would fill the hollows and provide pools for birds, low shapes would offer seating to the public and the environments created by the sculptures would be attractive areas for children to play in. In 1978 he made another cast-iron public outdoor sculpture, *Camera* [71], for the grounds of the European Patent Office in Munich. The arena-like shape was derived from a blueprint for a camera but it also suggests a geological or an architectural form. His most ambitious scheme for a German site was the *Rheingarten Project* of 1980 [72]. On the river bank in the centre of Cologne, between the Deutz and Hohenzollern Bridges, Paolozzi designed a whole series of geometric, quasi-mechanical shapes to celebrate the fact that the motor car had been driven underground. The Rheingarten, once a road, had become a recreational area. The models for all these projects are in the Scottish National Gallery of Modern Art.

During his time in Cologne Paolozzi took part in a project to celebrate the city. His contribution was a series of prints using the interior of Cologne Cathedral as the setting for fantastic installations of a wide variety of images and artefacts from natural history, science, space travel, aviation and art. He also included cars, a bicycle, dancing girls and the masterpiece of ancient Greek sculpture, *The Laocoön*, a group of figures wrestling with a snake. This series of prints, *Mein Kölner Dom: Blueprints for a New Museum* [73], was playful, innovative and surreal.[42] The prints were based on collages of cut-out pictures, Paolozzi's favourite medium for expressing ideas.

In London in 1980 Paolozzi began work on two projects. The first was a commission by British Railways to create a sculpture for the forecourt of Euston Station. He made a 'machine head' shape which he named after the revolutionary German theatre director, Erwin Piscator [74]. The source for the base element was a motorbike engine [75] which he then transformed into a more organic shape [76]. The crown of stepped elements was made to be seen by people working in the office blocks above the sculpture.[43]

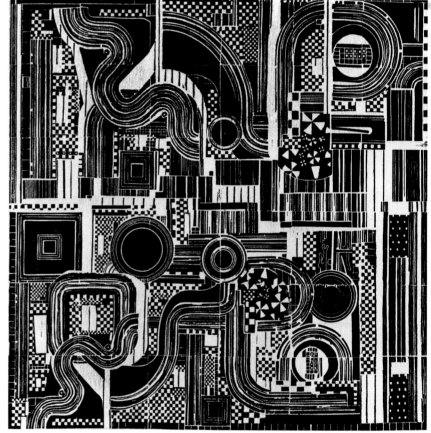

69

1980–1

Mein Kölner Dom: Blueprints for a New Museum, set of six lithographs and screenprints.

1981

Saltire Society Award for cast aluminium doors for Hunterian Art Gallery, University of Glasgow. Hon. Member Architectural Association, London. *Piscator* at Euston Square for British Railways Board. One-man exhibition in Salzburg.

1981–91

Professor of Sculpture at the Akademie der bildenden Künste in Munich. Drew in the Munich Glyptothek and became fascinated once more with the human body.

1981–2

Master Class, International Summer School, Salzburg, where the emphasis was on working with paper. A *Perspective on Innovation* tapestry for Institute of Chartered Accountants, woven by Edinburgh Tapestry Company (Dovecot Studios).

1981–2

Mosaics for Milward Square, Kingfisher Shopping Centre, Redditch.

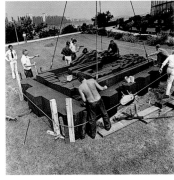

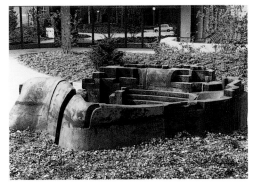

70

71

72

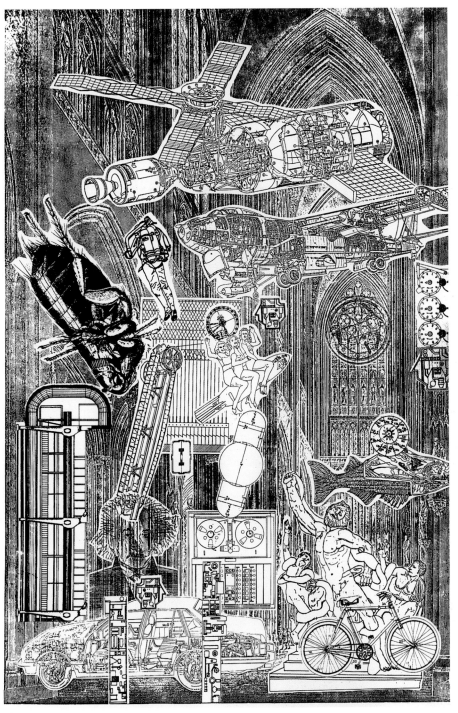

73

[69] *For the Four from For Charles Rennie Mackintosh* 1975
Woodcut
Presented by the artist 1998

[70] *Hommage to Anton Bruckner being positioned outside the Brucknerhaus, Linz, Austria* 1977

[71] *Camera* 1978
Cast iron
European Patent Office, Munich

[72] *Detail of Rheingarten Project in Cologne* 1980–6
Bronze, stone and water

[73] *Print from Mein Kölner Dom: Blueprints for a New Museum* 1980–1
Lithograph and screenprint
Presented by the artist 1998

The second project of 1980 was a commission to decorate the London Underground Station of Tottenham Court Road [77]. Paolozzi said of it: 'My "alphabet" of images for Tottenham Court Road reflects my interpretation of the past, present and future of the area. Specific representational elements are interwoven with geometrical and musical rhythm lines–metaphors exist on many levels simultaneously. The cross-section of the camera refers to local shops as well as to tourists; an engine / ethnographic mask evokes not only the British Museum but also the diversity of backgrounds of local inhabitants and the automotive traffic above ground.'[44] These brightly coloured mosaics for the Central Line, with their stylised robot faces, saxophones and hieratic patterns, were in contrast with the more abstract patterns in black and white that he designed for the Northern Line.

[74] *Piscator* 1981
Cast iron
Euston Station, London

[75] *Portrait of Matta* and two
Naked Head sculptures 1978
Presented by the artist 1998

[76] *Head Looking Up* (left and centre) and *Small Head* (right) 1980
Presented by the artist 1998

[77] **Model of mosaics for Central Line platform, Tottenham Court Road Tube Station, London 1981–2**
Presented by the artist 1998

74

76

75

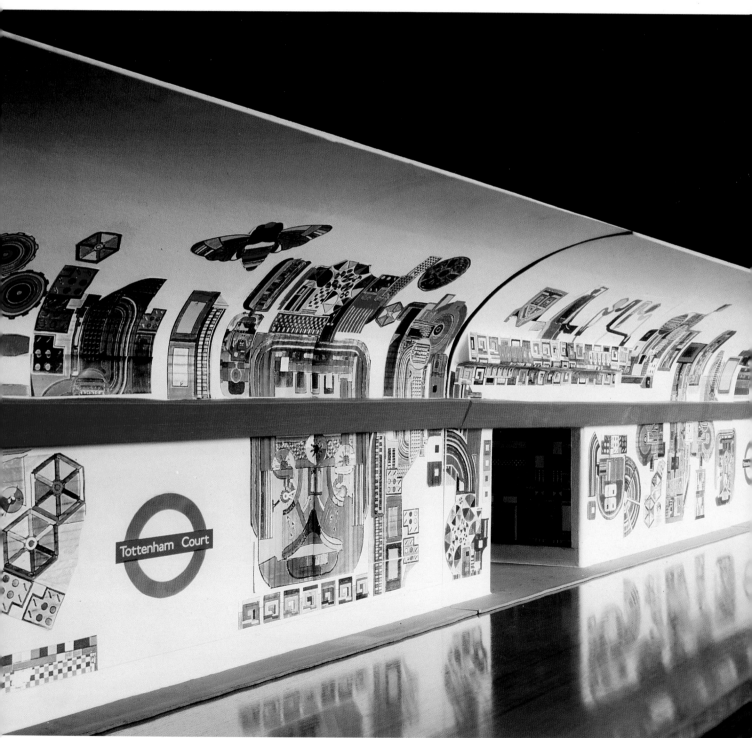

The Human Figure and Installations

In 1981 Paolozzi became Professor of Sculpture at the Akademie der bildenden Künste in Munich. While there he became a regular visitor to the Glyptothek and, with his students, drew regularly from antique figure sculpture [78]. His old obsession with metamorphosing the human figure reasserted itself and by 1984 he had created a series of fragmented heads which blend geometry with nature [79 and 80]. 'By using the Surrealist technique of the cut he is able to explore expression beyond physiognomy', remarked Robin Spencer.[45] As with the *Time* collages of the 1950s [22], Paolozzi deconstructed and reconstructed the human head. Horizontal and vertical cuts are filled with geometrical fragments suggesting mechanisation.

One of the artist's friends has suggested that Paolozzi has never lost the child's ability to play, with the result that a freshness of vision and spontaneity inform all his work.[46] Paolozzi has in fact created several children's playgrounds, the most recent being in 1982 for Pesch in Cologne [81], consisting of a variety of geometric shapes and linking struts, both curved and straight. The fact that Paolozzi still creates small sculptures for his own pleasure out of a sense of fun is a measure of his playful inventiveness. Paolozzi is familiar with the writings of Freud on the creativity of play and it is this playfulness that informs his working method.

Paolozzi has said that all cultures need to preserve the possibility of a sense of mystery and wonder. This belief ensures that he has changed from decade to decade as his interests have widened and developed. Although closely linked to Nigel Henderson and the Independent Group in the 1950s, Paolozzi worked through his own personal obsessions in the subsequent decades. One can see parallels in the works of Daniel Spoerri, Ed Kienholz and Robert Rauschenberg in the way that found objects are used to create installations. However, Paolozzi did not really develop this aspect of his work until 1985 when he co-curated the *Lost Magic Kingdoms* exhibition with Malcolm Mcleod at the Museum of Mankind in London [82]. For this show he used the ethnographic collection together with found objects and his own work to create a series of installations. Like the 1972 Royal Academy installa-

[78] **Paolozzi drawing in the Munich Glyptothek c.1989**

[79] **Paolozzi working in his room at the Royal College of Art, London 1985**

78

79

1982

Cast-iron reliefs sprayed with aluminium for Cooling Tower, Bessborough Street, by Pimlico Tube Station, London. *Children's Playground* for Pesch, Cologne. *Anniversary Tapestry*, Engineering Building, University of Leicester. Artistic Consultant for Richard Rogers and Partners' bid to build the new extension to the National Gallery, London. Exhibition of prints in Hamburg.

1983

Began making fragmented human heads. Grand Prix d'Honneur, 15th International Print Biennale, Ljubljana, Yugoslavia. Floor mosaic commis-

Catastrophe Fountain for garden exhibition, West Berlin.

1982–4

sioned by Charles Jencks. February–March: *Eduardo Paolozzi: Kunst und Bau: Architectural Projects*, Aedes Galerie für Architektur und Raum, Berlin.

1983–4

Exhibition of prints in Berlin.

1984

Retrospective at the Royal Scottish Academy, Edinburgh and tour to Munich and Cologne (1985). Glass mosaic murals for Tottenham Court Road Underground Station. Film sets for Percy Adlon's *Herschel and the Music of the Stars*.

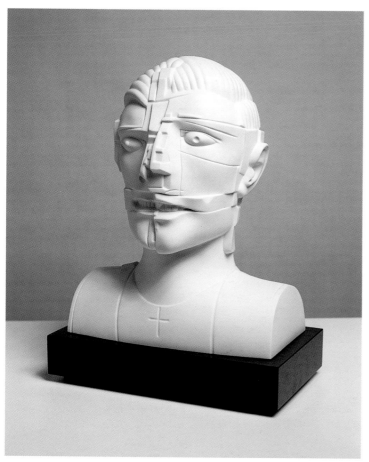

80

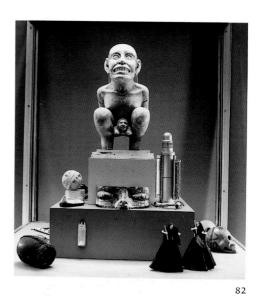

[80] *Porcelain Head* manufactured
by Rosenthal *c.*1984
Presented by the artist 1998

[81] **Model for** *Children's Play-*
*ground in Pesch, Cologne c.*1982
Wood
Presented by the artist 1998

[82] **Case installation from** *Lost*
Magic Kingdoms **exhibition** 1988–9

82

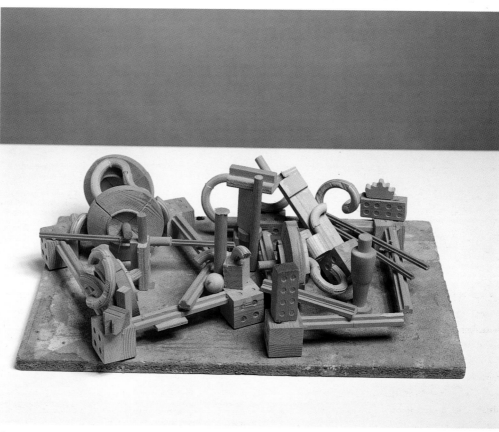

81

tion, *Thunder and Lightning with Flies and Jack Kennedy*, it made comments upon contemporary civilization. The way in which Paolozzi built up layers of references was a sort of three-dimensional collage.

From about 1983 onwards Paolozzi explored the morphology of the human form in a series of heads. *Yukio Mishima* [83], *Count Basie* [84] and *The Critic* brought together a mixture of facial features, some modelled after dummies, some cast from found objects and some with geometric inserts. For the monumental composition outside the Design Museum in London, *The Head of James Watt After Newton* 1990, Paolozzi took a naturalistic human head and deconstructed it. The work bears an inscription from Leonardo da Vinci: 'Though human genius in its various inventions with various instruments may answer the same end, it will never find an invention more beautiful or more simple or direct than nature, because in her inventions nothing is lacking and nothing superfluous.' It marks Paolozzi's return to the human form but in a manner that draws directly from nature. Paolozzi has had a lifelong fascination with Leonardo, his chronicling of the world around him and his fantastic inventions.

In the mid-1980s Paolozzi used nature and geometric shapes in his treatment of the human figure. He transformed a series of naturalistic self-portraits into figures such as *Self-Portrait with a Strange Machine* [85] and *The Artist as Hephaestus* [86]. These have abstracted torsos and legs made up of geometric shapes and planes, which turn them into semi-robots. The figures hold in front of them a strange array of objects including a sieve and a sphere drawn from the imagery of genetic engineering. The most monumental group on this last theme, *Leonardo* 1986 [87], was based on a *National Geographic* diagram of genetic engineering.

In 1988, working from nature, Paolozzi made finely detailed, realistic heads of the architect Richard Rogers. He showed the architect at first serious [88], then smiling [89], very much in the manner of the eighteenth-century Austrian sculptor Franz Xavier Messerschmidt. Paolozzi then split both heads down the centre and collaged together two different sides, adding horizontal cuts and inserting geometric pieces [90]. This process of destruction prior to remaking from fragments is a working method that Paolozzi traces back to Rodin and Picasso.[47] For the exhibition *Noah's Ark* held in Munich in 1990 Paolozzi attached cast body parts to the torsos of puppets which he obtained from the Munich Puppet Theatre [91].

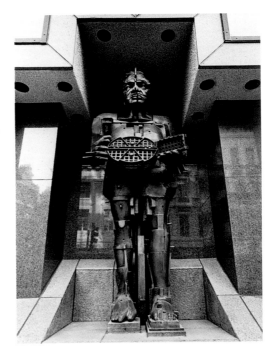

86

[83] *Yukio Mishima* 1984
Bronze
Presented by the artist 1998

[84] *Count Basie* 1987
Bronze
Presented by the artist 1998

[85] *Self-portrait of the Artist with a Strange Machine* 1987
Bronze
Presented by the artist 1998

[86] *The Artist as Hephaestus* 1987
Bronze
High Holborn, London

[87] *Leonardo* 1986
Cast iron
Alte Pinakothek, Munich

1985

Lost Magic Kingdoms exhibition curated with Malcolm Mcleod at the Museum of Mankind, London: ethnographic artefacts from the collection with works by the artist on themes such as colonialism, packaging, animals and recycling.
The Krazy Kat Arkive, a vast collection of popular culture and artefacts was gifted by Paolozzi to the Victoria and Albert Museum, London.

1986

Made Fellow of University College, London. Appointed Her Majesty's Sculptor-in-Ordinary for Scotland. Constructed wood relief, *On This Island*, in Queen Elizabeth II Conference Centre, London in tribute to Benjamin Britten and W. H. Auden.
Eduardo Paolozzi: GUA 5000, publication commemorating a relief made for oil platform, North Sea Sun Oil Balmoral. *Leonardo*, cast-iron sculpture for grounds of Alte Pinakothek, Munich.

1987

Hon. D. Litt. Heriot-Watt University, Edinburgh; Hon. D. Litt. University of London. Naming of Eduardo Paolozzi Art School in Ipswich. *The Artist as Hephaestus* for 34–36 High Holborn, London. *Paolozzi: Sculptures from a Garden*, Serpentine Art Gallery, London (touring exhibition of works from Gabrielle Keiller collection).

1988

Paolozzi Portraits, exhibition at

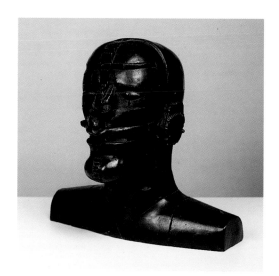

83

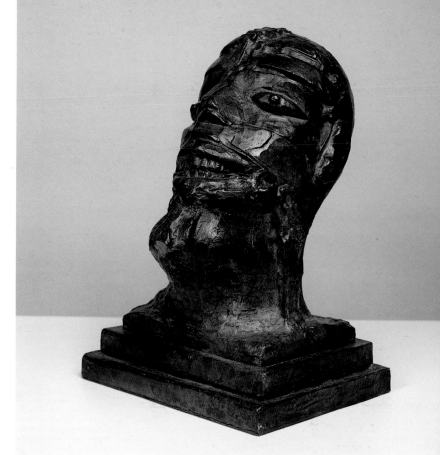

84

85

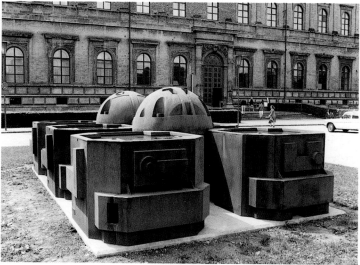

87

the National Portrait Gallery, London, including their commissioned portrait bust of Richard Rogers. Trustee of National Portrait Gallery. Bronze, *The Concept of Newton*, for Kowloon Park, Hong Kong. Exhibition of works created as a result of lessons held in the Munich

Glyptothek, by Paolozzi and his students in Munich.

1989
Knighted. *Master of the Universe* bronze purchased by Scottish National Gallery of Modern Art, Edinburgh. Exhibitions in Edinburgh and Munich.

1990
Noah's Ark, exhibition in Stadtmuseum, Munich, drawn from the collection of the Puppet Museum with additions by the artist. Corresponding member Bayerische Akademie der Schönen Künste. *Eduardo Paolozzi: Mythologies. A Retrospective Survey 1946–1990*, The Scottish Gallery, London. Neal Street Restaurant relief for Antonio Carluccio and brass screen for The Ivy Restaurant, London. *Newton After James Watt*, giant head for the Thames Embankment outside the Design Museum, London. *Egypt*, bronze hand for Wilhelm Lehmbruck Museum, Duisburg, Germany.

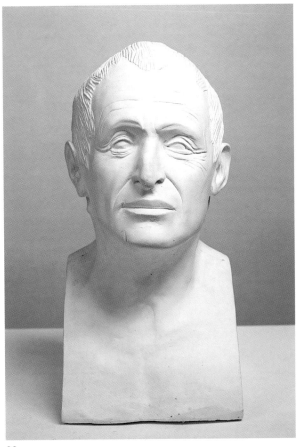

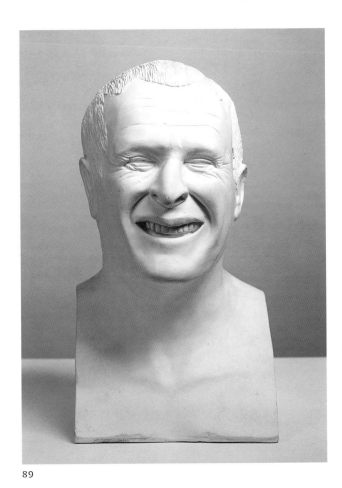

88

89

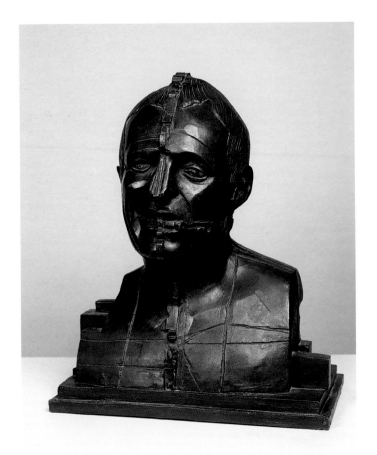

90

[88] *Richard Rogers (unsmiling)*
1988
Plaster
Presented by the artist 1998

[89] *Richard Rogers (smiling)*
1988
Plaster
Presented by the artist 1998

[90] *Richard Rogers* **1988**
Bronze
Presented by the artist 1998

[91] **Installation photograph of**
Noah's Ark exhibition 1990

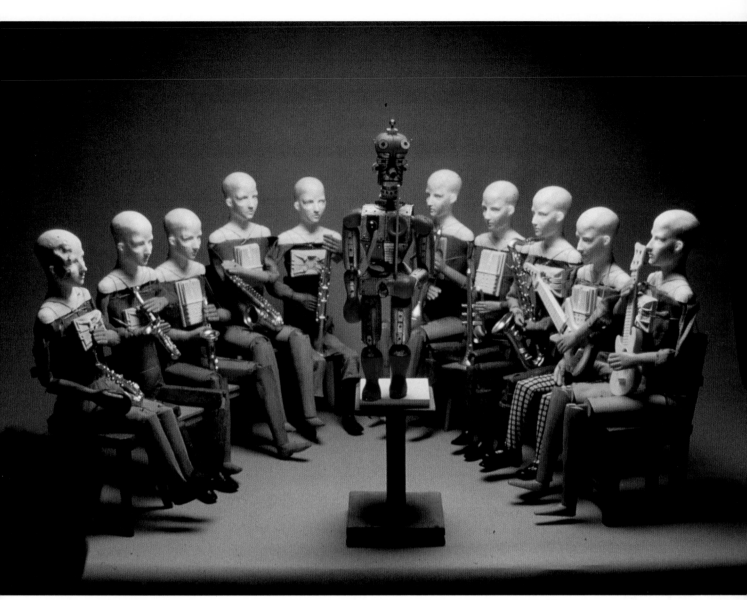

Edinburgh Commissions

The large multi-part outdoor sculpture, *The Manuscript of Monte Cassino*, made for the top of Leith Walk in Edinburgh is a homage to Paolozzi's Italian roots [92]. Its situation outside the Roman Catholic Cathedral also makes reference to his early life in Leith. Fragments from the old Leith Central Station, near his birthplace in Crown Place, were placed in flower beds next to the sculpture. The composition consists of an enormous foot, an ankle and an open hand all bordered by the inscribed text of the manuscript. This ancient text, from the archives of the Abbey at Monte Cassino, is addressed to the Deacon Paul; it recalls the hospitality and peace that the weary traveller can find with the Brothers.

Two years later Paolozzi created another composition made of body parts entitled (after the great Scots philosopher and economist Adam Smith) *The Wealth of Nations* [93]. This monumental bronze was commissioned by the Royal Bank of Scotland and placed outside their headquarters at South Gyle on the outskirts of Edinburgh. It bears a quotation from Einstein to the effect that knowledge is good but imagination is greater. Paolozzi developed for this work a series of hands grasping rods which look back not only to the insignia for Hammer Prints but also to antique sculpture fragments in the Munich Glyptothek. The final work suggests a reclining figure with a large cubist head on its side, two hands holding rods and two realistically modelled feet [94]. The area where the main part of the body should be is taken up by rectangular shapes and curved bands linking the head and limbs together.

In 1996 Paolozzi took this vocabulary of forms further by collaging them together with ribbed torsos, arms and legs to form two tall standing figures which flank a doorway of the Swan Building at King's Buildings, University of Edinburgh science campus [95 and 96]. The disjointed figures are perhaps the nearest Paolozzi has come to the work of his hero, Francis Bacon. Paolozzi has said: 'I think that the race towards destruction is colossal ... Perhaps the most moving metaphor is in the work of Francis Bacon who shows the whole dilemma. He's finalised it into the human figure ... Pinter has used the phrase that we're all spiralling remorselessly toward self-destruction–you can either use art as a kind of mirror to your soul, but you can also use it as a kind of shield.'[48] Paolozzi's considered choice of planet names for his King's Buildings figures, *Parthenope* [95] and *Egeria* [96], taken from a school book on Newton, suggests a mythic embodiment of human biology, the discipline studied in the adjacent building.

95

96

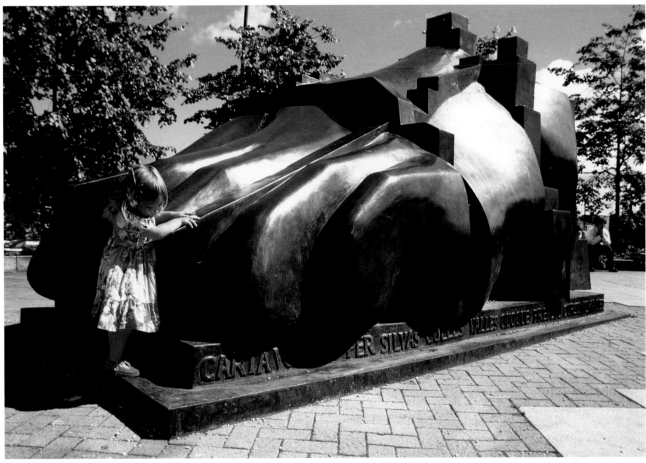

92

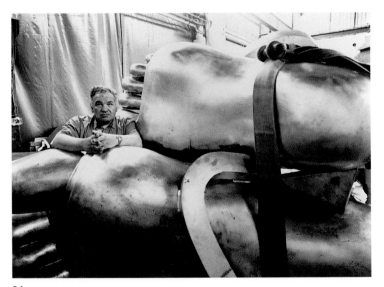

94

[92] *Manuscript of Monte Cassino*
1991
Bronze
Picardy Place, Edinburgh

overleaf [93] *The Wealth of Nations* 1993
Bronze
South Gyle, Edinburgh

[94] **Paolozzi with the cast feet for** *The Wealth of Nations* **sculpture**

[95] *Parthenope* 1997
Bronze
King's Buildings, Edinburgh

[96] *Egeria* 1997
Bronze
King's Buildings, Edinburgh

ment of cataloguing. Tapestry for London head office of Pearson. *Portrait of Wittgenstein*, print for Jesus College, Cambridge where Paolozzi is a Fellow. Medal for the Trustees of the National Galleries of Scotland. Invited to submit for Oscar

Wilde Memorial. Monumental figure of *Newton* placed outside British Library.

1996
Large room installation, *Jesus Works in Store*, in *Spellbound* exhibition, Hayward Gallery,

London, paying tribute to the cinema. Included in *Un Siècle de Sculpture Anglaise*, Galerie Nationale du Jeu de Paume, Paris. *Artificial Horizons and Eccentric Ladders: Eduardo Paolozzi Works on Paper*, British Council touring exhibition.

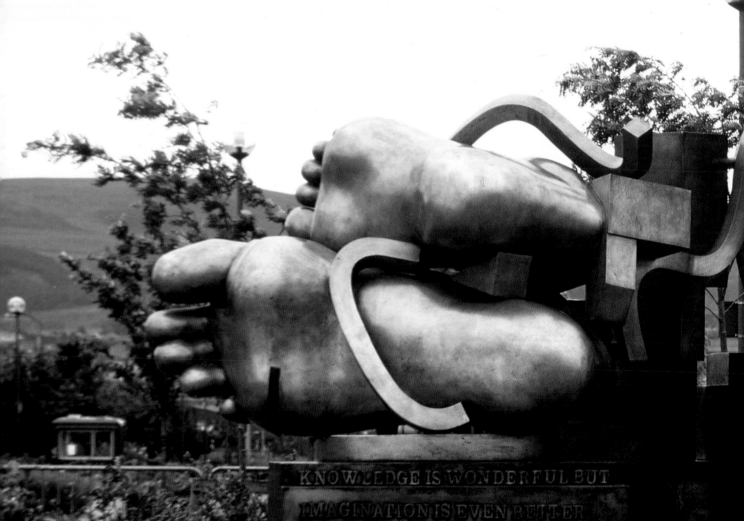

KNOWLEDGE IS WONDERFUL BUT
IMAGINATION IS EVEN BETTER

EINSTEIN

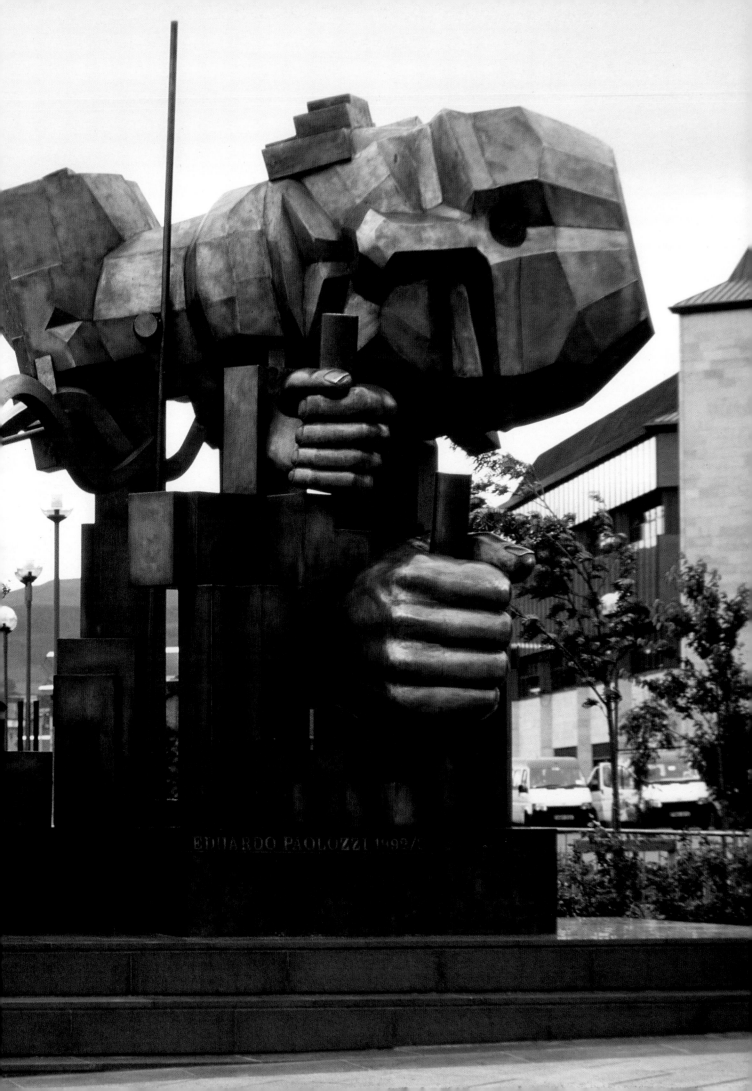

Newton

Newton has been an interest of Paolozzi's for many years. He has long admired William Blake's image of the famous thinker and scientist in the Tate Gallery. He adopted the pose and mechanised the figure [97] in order to make *Master of the Universe* [98]. The initial maquette followed Blake's painting, while the later, monumental version of the composition, returned to a more smoothly realistic figure but with thickened and rounded forms. Whereas *Master of the Universe* is blind, the monumental *Newton*, commissioned for the new British Library in London [99], was given the eyes of Michelangelo's *David*.[49] The

figure was finally unveiled in 1997, two years after completion. The full-size plaster is in the Gallery of Modern Art's collection along with two smaller studies, two reliefs and the finished bronze of *Master of the Universe*. Paolozzi enjoys the ironic tension between Blake's castigation of Newton's wish to order the universe and the accepted wisdom that one should celebrate Newton's intellect and discoveries.

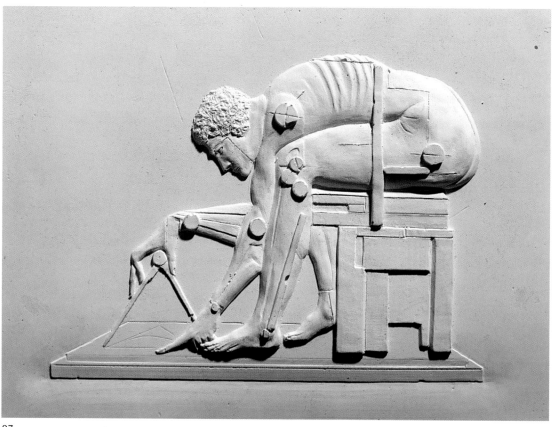

97

1997

Monumental bronze figures of *Parthenope* and *Egeria* set up outside Swan Building at King's Buildings, University of Edinburgh science campus. Commission by National Museums of Scotland for twelve bronze figures for the new Museum of Scotland. *Duck Farm and Studio Interior*, prints and new installations for exhibition at Jason Rhodes Gallery, London. *Josephine Baker*, bronze figure commission for Selfridges department store, London. Work in progress on figure for Kew Gardens, London.

1998

Paolozzi: Life in Art: Art in Life, exhibition of Robin Spencer's Collection at the Crawford Arts Centre, University of St Andrews, including new *Circus* suite of four prints. Given commission for new doors for west front of St Giles Cathedral, Edinburgh. Commissioned to produce postage stamp on theme of computers. At work on a monumental figure for the Dean Gallery, Edinburgh, commissioned by the Patrons of the National Galleries of Scotland. Deed of Gift to the National Galleries of Scotland signed.

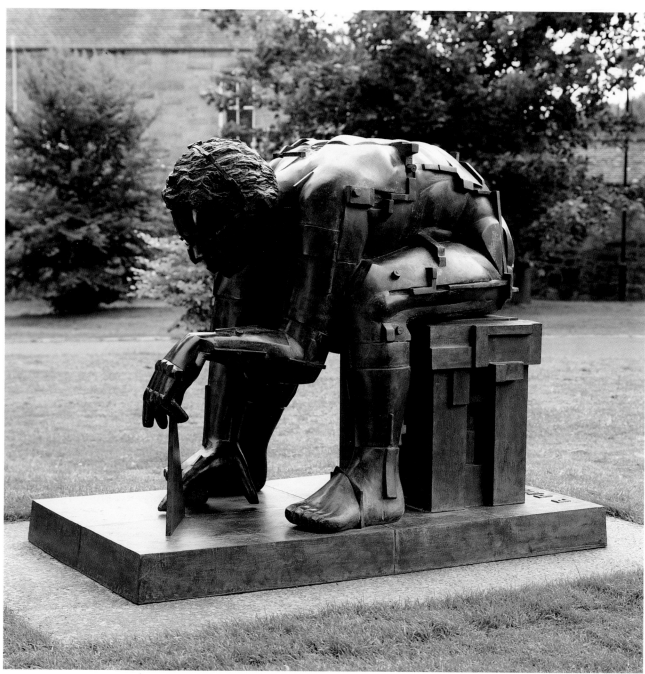

98

99

[97] *Newton c.*1994–5
Plaster relief
Presented by the artist 1998

[98] *Master of the Universe* 1989
Bronze

[99] Paolozzi and Cherie Blair
at the unveiling of *Newton* at
the British Library, London
1997

Recent Work

In 1998 Paolozzi was hard at work on a wide range of sculptures. He made a large bronze figure of Josephine Baker for Selfridges department store in London and new suites of prints showing the interior of his studio, a circus and a duck farm. Over the past few years he has been working on figures for Kew Gardens, for the Dean Gallery and the new Museum of Scotland. He has also been commissioned by the Church of Scotland to make new doors for St Giles Cathedral in Edinburgh.

The main character of Paolozzi's work of the past two decades has been monumental, fulfilling public commissions. However, he has also worked on small heads for his own pleasure. In the mid-1990s Paolozzi developed a cubist head. This new departure was inspired by a schematized head taken from computer graphics. The shape was pared down to a series of geometric facets. These were then sawn through vertically and horizontally and pegs were inserted. The resulting grid effect led Paolozzi to call them *Mondrian Heads* because they reminded him of Mondrian's late 'boogie woogie' paintings [100]. Paolozzi says they seem to be a 'successful amalgam of something I've been striving for, which is African art, psychopathic art, geometric art, art which takes care of the machine and in addition to that, lubricated and bound together by Broadway boogie woogie, saying in other words that you can't evade modernism; if you try and avoid modernism you're dead.'[50]

[100] *Large Mondrian Head* 1993
Bronze
Presented by the artist 1998

[101] Installation *Jesus Works in Store* made by Paolozzi for the exhibition *Spellbound* at the Hayward Gallery, London 1996
The sphinx is derived from an antique sculpture in the Freud Museum and the photograph is a still from the film *Reefer Madness*

[102] Interior of Paolozzi's rear studio in London 1994

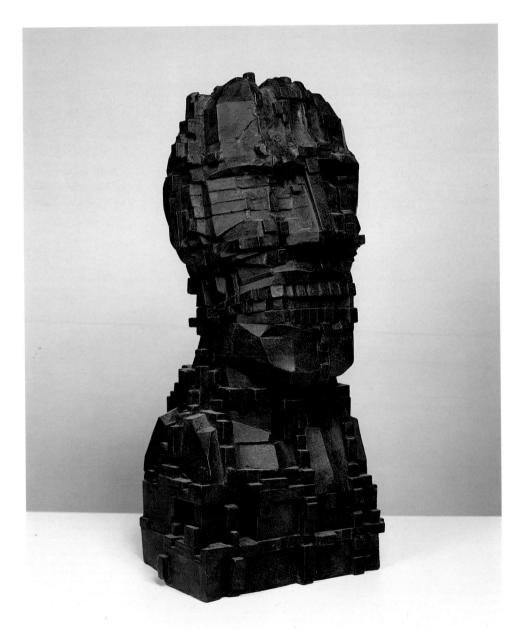

100

Sources

Paolozzi's extraordinary ability to invent new forms is fed by his wide-ranging interests. A survey of his library reveals an enormous appetite for information. Paolozzi looks at every conceivable aspect of world affairs, past civilisations and realms of the imagination as expressed in the arts. A sample of the published works that fire him were listed in a short bibliography made for his students in January 1980.[51] In it he included not only Ozenfant's *Foundations of Modern Art* but also Harald Szeemann's *Les Machines Célibataires*, Christopher Hill's *The World Turned Upside Down*, Siegfried Giedeon's *Mechanization Takes Command*, *The Robot Book*, books by the architectural writer Charles Jencks, books on Francis Bacon, Michelangelo, Max Klinger, Aby Warburg, James Ensor, Paul Gauguin, Frank Lloyd Wright and Luis Buñuel. His slide collection, based on thousands of tearsheets, covers every topic from ethnography to space travel to music. Paolozzi, once asked why he collected so many newspaper cuttings, said he wanted to make sense of 'all this' and described the shape of a globe.[52] Paolozzi is acutely concerned with the fate of the earth. His 1979 writings forecast the struggles of the Greenpeace protesters.[53] He comments upon 'throwaway' consumerism, first unconsciously in his earliest scrapbooks as a teenager, then in the McLuhan-informed *Bunk* 'lecture' of 1952 where it is still a celebration of consumerism but tinged with a new self-awareness. However, the waste skips of 1971 and the sea of rubbish in *Noah's Ark* of 1990 contain unmistakable references to the disposable society. Finally, the lumber room installation for the 1996 Hayward Gallery exhibition *Spellbound*, with its accretions of relics of countless films [101], is a reminder of the value of our artistic past.

Throughout his teaching career Paolozzi has made a point of giving lecture presentations of slides which mix disparate images, in the Surrealist tradition. He has sought to give his students a new view on the world by this sort of kaleidoscope of information. This demonstration of his thought processes, whereby he transforms objects by putting them in a new context, draws you into his world. The theatrical nature of the lecture appeals to Paolozzi's sense of performance. It is a personal development based upon Surrealism. Paolozzi also takes books and rips them apart, page by page. He liberates the images in front of an audience and it is hypnotic. The boxes of tearsheets, postcards and CDs are the equivalent of lectures. In conversation his topics are as diverse as the information he has been gathering. In his studio he listens to the radio at all times of the day and night. He reads two or three newspapers every day. His consumption of books is steady, with about three titles on the go at any one time. He scans for information, extracting the meat of a book, magazine, newspaper or exhibition in a very short time. The function of all this activity is the feeding of his imagination. The layering of every surface in the studio is symptomatic of Paolozzi's thought processes [102].

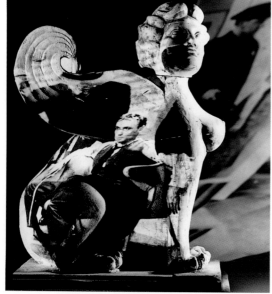

101

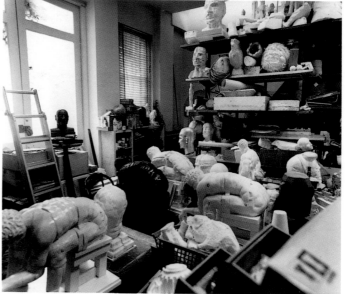

102

[103] *Sir Eduardo Paolozzi, Sculptor 1988*
Photograph by Snowdon

Postscript

Despite all his links with the establishment, Paolozzi remains refreshingly objective about the status quo.[54] Throughout his life he has been an outsider. By the same token his clarity of vision has made him uniquely placed to describe the world. Paolozzi has a gift for diagnosing people and places. He is an extraordinary communicator, not only through language but also by look or gesture. The *Bunk* 'lecture' of 1952 was verbalised only as a series of grunts as the images were shown but he still had the ability to disturb the audience. This wrongfooting of mainstream thinkers has stayed with Paolozzi throughout his life. The satire inherent in his 1971 retrospective exhibition at the Tate Gallery confounded the critics. In each decade of his working life he has deconstructed himself and emerged in a new guise. The sheer inventiveness of his *oeuvre* is exceptional.

A comprehensive anthology of Paolozzi's writings will be published during 2001.[55] The texts will include catalogue essays, collage texts, interviews, poetry and lectures. His recently revived interest in writing poetry underlines the visionary nature of his work. Coupled with his fascination for images of the machine age it reveals to what extent he is intent on bringing art and science together. It has been said that if there were a holocaust, one could reconstruct the twentieth century from the images shown in Paolozzi's work.[56] The collage prints, the collage sculptures and the collage texts are all amalgams of significant thoughts, personalities and events of this century. Paolozzi's deep appreciation of theatre, music, cinema and literature is based upon a vigorous engagement with life. He has followed Ozenfant's dictum: 'Art is the demonstration that the ordinary is extraordinary'.[57] Paolozzi is a master of contradictions. In 1990 he wrote: 'If the world does not fit any more, how does man? A sculptor in the urban world must concern himself with the contradictions of man and machine, with bizarre hidden currents of antiquity, religion and magic–he must use his vision to open wider views to others.'[58] There surely can be no better summary of the beliefs of an artist who has spent his life exploring every aspect of the world around him in order that we might have a better vision of reality, of ourselves and the hidden potential of every situation. We may not understand all the layers of references in his work but we can recognise a sense of wonder in both the microcosm and the macrocosm.

> For now I have the answer from the face
> That never will go back into a book
> But asks for all my life, and is the Place
> Where all I touch is moved to an embrace,
> And there is no such thing as a vain look.[59]

Notes and References

1

His full name was Alfonso Rodolfo Armando Antonio Paolozzi and he later took to calling himself Rudolfo. Information from Yolanda Tartaglia and Eduardo Paolozzi.

2

Pietro Rossi had a flat at 285 Leith Walk and a confectionery shop at 55 Leith Walk. Information from Edinburgh District Council Valuation Rolls, Edinburgh Room, Central Library, Edinburgh.

3

Information from Registrar General for Scotland, New Register House, Edinburgh.

4

Information from Edinburgh District Council Valuation Rolls, Edinburgh Room, Central Library, Edinburgh.

5

The details from this period of his life derive either from the typescript of a 1994 series of interviews with Frank Whitford (courtesy Robin Spencer, University of St Andrews) or from conversations with the artist.

6

Information from Edinburgh College of Art Archives, Heriot-Watt University.

7

'A Childhood: Sir Eduardo Paolozzi talks to Ray Connolly', *The Times: Saturday Review*, 8 September 1990.

8

Ibid.

9

This period is described in the Whitford interview (see note 5). See also W. Konnertz, *Eduardo Paolozzi*, Cologne 1984, p.20, for an illustration of Paolozzi's discharge papers.

10

Obituaries: *The Independent*, 30 June 1998; *The Guardian*, 10 July 1998.

11

These annotated publications are in the Archive of the Scottish National Gallery of Modern Art.

12

See W. Konnertz, op. cit., pp.27–31 for illustrations.

13

Typed text signed and dated August 1978. Originally written for the catalogue of a touring exhibition entitled *State of Clay* organised by Sunderland Art Centre. Archive, Scottish National Gallery of Modern Art.

14

Johnstone initially offered this post as a temporary measure until a post in fine art was available. However, Paolozzi was a great success in the textile department and stayed on in that post. See William Johnstone, *Points In Time: An Autobiography*, London 1980, pp.261–2.

15

See Central School of Art and Design prospectuses for 1950–55. These are held by the Central St Martin's College Archive which is housed in the original Central School building on the corner of Theobald's Road and Southampton Row. (The Central School has now merged with St Martin's School of Art.)

16

See Judith Collins's essay in *Artificial Horizons and Eccentric Ladders*, exhibition catalogue, British Council, 1996, Talbot Rice Gallery, Edinburgh and tour.

17

He has even made a print after the plan of an ideal city by Frank Lloyd Wright, which he called *Utopia*. Proofs exist at the Scottish National Gallery of Modern Art.

18

Andrew Causey, *Sculpture Since 1945*, London 1998, pp.77–81, discusses the competition. See also Richard Calvocoressi, *Reg Butler*, Tate Gallery, London 1983; Robert Burstow, 'Butler's Competition Project for a Monument to "The Unknown Political Prisoner": Abstraction and Cold War Politics', *Art History*, Vol.12, No.4, Dec. 1989, pp.472–96; Robert Burstow, 'The Limits of Modernist Art as "Weapon of the Cold War": reassessing the unknown patron of the monument to the Unknown Political Prisoner,' *The Oxford Art Journal*, Vol.20, No.1, 1997, pp.68–80; Axel Lapp, 'The Freedom of Sculpture, The Sculpture of Freedom: The International Competition for a Monument to the Unknown Political Prisoner, London 1951–55', *The Sculpture Journal*, Vol.2, 1998, pp.113–122.

19

See essay on Henderson by James Lingwood in *The Independent Group: Postwar Britain and the Aesthetics of Plenty*, exhibition catalogue, ed. David Robbins, Institute of Contemporary Arts, London 1990, pp.76–86.

20

A Nigel Henderson exhibition is in preparation for showing at Gainsborough's House, Sudbury, and the Scottish National Gallery of Modern Art.

21

See essay by Richard Calvocoressi, 'Public Sculpture in the 1950s', in book *British Sculpture in the Twentieth Century*, eds. Sandy Nairne and Nicholas Serota, Whitechapel Art Gallery, London 1981, p.143.

22

The Independent Group: Postwar Britain and the Aesthetics of Plenty, London 1990, loc. cit.; Anne Massey, *The Independent Group: Modernism and Mass Culture in Britain 1945–59*, Manchester 1995.

23

Uppercase, No.1, 1958, unpaginated.

24

E. Roditi, *Dialogues on Art*, London 1960, p.162.

25

David Mellor, *The Sixties Art Scene in London*, Barbican Art Gallery, London 1993, p.22.

26

Roditi, op. cit., p.159.

27

Ibid., p.155.

28

M. Middleton, *Eduardo Paolozzi*, London 1963, unpaginated.

29

D. Kirkpatrick, *Paolozzi: Sculptures, Drawings, Prints 1949–1968*, British Council, 1978, quoting from Eduardo Paolozzi, 'Notes from a Lecture at the ICA', *Uppercase* No.1, 1958, unpaginated.

30

D. Kirkpatrick, *Eduardo Paolozzi*, London 1970, p.27.

31

John Steer and Robin Spencer, *Eduardo Paolozzi: The Conditional Probability Machine*, St Andrews University, exhibition catalogue, 1972, p.2.

32

Kirkpatrick 1970, op. cit., p.65.

33

Ibid, pp.79–83.

34

M. Middleton 1963, loc. cit.

35

Bryan Robertson, John Russell, Lord Snowdon, *Private View*, London 1965, p.77.

36

For a survey of Paolozzi's work in printmaking up to 1977, see Rosemary Miles, *The Complete Prints of Eduardo Paolozzi: Prints, Drawings, Collages 1944–77*, exhibition catalogue, Victoria & Albert Museum, London 1977.

37

Frank Whitford, Interview typescript, loc. cit.

38

Eduardo Paolozzi: Nullius in Verba, exhibition catalogue, Talbot Rice Art Gallery, Edinburgh University 1989. Interview with Paolozzi by Bill Hare and Andrew Patrizio, p.43.

39

Frank Whitford, Interview typescript, loc. cit.

40

Ibid.

41

Eduardo Paolozzi: Sculptures, Drawings, Collages and Graphics, exhibition catalogue, Arts Council of Great Britain, 1976–1977, p.35.

42

For Paolozzi's own description of this project see E. Paolozzi, 'Where Reality Lies', *The Oxford Art Journal*, Vol.6, no.1, 1983, pp.39–44.

43

Information from the artist.

44

Eduardo Paolozzi: Underground, exhibition catalogue, Royal Academy of Arts, London 1986, p.8.

Further Reading

45

Paolozzi Portraits, exhibition catalogue, with an essay by Robin Spencer, National Portrait Gallery, London 1988, p.16.

46

Rudi Seitz, in an interview on BBC Radio, 3 March 1984, quoted in *Art in Europe: Eduardo Paolozzi: From Munich Collections: Prints and Sculptures*, exhibition catalogue, European Patent Office, Munich 1996. Seitz, a child psychologist, was the Rector of the Munich Academy of Fine Arts during the time Paolozzi taught there.

47

Paolozzi discusses this use of fragments in an interview with his colleague at the Royal College of Art, Glynn Williams, in 'Inside the Art World: Glynn Williams Talks to Eduardo Paolozzi', *Sotheby's Art At Auction: The Art Market Review 1994–95*, London 1995, p.43.

48

Eduardo Paolozzi: Nullius in Verba, op. cit., p.44.

49

Information from the artist.

50

Frank Whitford, Interview typescript, loc. cit.

51

Manuscript in the Scottish National Gallery of Modern Art's Archive.

52

This was a question put by a Royal College of Art student to Paolozzi in the Technicians' room of the Ceramics Department of the Royal College of Art, where Paolozzi has a desk, strewn with piles of newspapers and cuttings.

53

See essay by Paolozzi, 'Junk and the New Arts and Crafts Movement', July 1979, for a published exhibition catalogue, *Eduardo Paolozzi*, Talbot Rice Art Gallery, Edinburgh University, 18 August–22 September 1979, unpaginated. Photocopy and manuscript in the Scottish National Gallery of Modern Art's Archive.

54

Paolozzi is an active member of the Royal Academy and the Royal Scottish Academy. He has served as a Trustee of the National Portrait Gallery in London and has been a donor to a large number of galleries, libraries and public institutions. Paolozzi became Sculptor-in-Ordinary to Her Majesty The Queen in Scotland in 1986 and was knighted in 1989. He is now the recipient of honorary degrees from Glasgow, Edinburgh, St Andrews and the Royal College of Art.

55

Edited by Robin Spencer and including a long essay, definitive chronology, exhibition and publication lists.

56

J. G. Ballard, for the film *EP Sculptor*, made by Barbara and Murray Grigor in 1984–5.

57

Amédée Ozenfant, *Foundations of Modern Art*, London 1931, p.323.

58

Eduardo Paolozzi: Mythologies. A Retrospective Survey 1946–1990, exhibition catalogue, Scottish Gallery, London 1990, p.23.

59

W. H. Auden,' The Prophets', from *Collected Shorter Poems 1930–1944*, London 1950, p.112. Paolozzi took volumes of poetry by T. S. Eliot and W. H. Auden with him to Paris in 1947.

Robert Melville, 'Eduardo Paolozzi', *Horizon*, Vol.XI, No.92, September 1947, pp.212–13

Michael Middleton, *Eduardo Paolozzi*, London 1963

Eduardo Paolozzi: Recent Sculpture, Drawings and Collage, exhibition catalogue by Richard Hamilton, Department of Fine Art, University of Newcastle-upon-Tyne 1965

Eduardo Paolozzi: Sculpture, Prints, exhibition catalogue, Scottish National Gallery of Modern Art, Edinburgh 1966

Diane Kirkpatrick, *Eduardo Paolozzi, A Study of His Art 1946–68*, Ph.D. thesis, University of Michigan, Ann Arbor 1969

Uwe Schneede, *Paolozzi*, Stuttgart 1970

Diane Kirkpatrick, *Eduardo Paolozzi*, London 1970

Eduardo Paolozzi (Retrospective), exhibition catalogue, Tate Gallery, London 1971, essay by Frank Whitford

Eduardo Paolozzi: Sculptures, Drawings, Collages and Graphics, exhibition catalogue, Arts Council of Great Britain touring show 1976, with texts by Frank Whitford, Robin Spencer, reprints by Wieland Schmied, Eduardo Paolozzi and interview with Paolozzi by Richard Hamilton

The Complete Prints of Eduardo Paolozzi, exhibition catalogue by Rosemary Miles, Victoria & Albert Museum, London 1977

Eduardo Paolozzi, 'Where Reality Lies', *The Oxford Art Journal*, Vol.6, No.1, 1983, pp.39–44

Eduardo Paolozzi: Private Vision–Public Art, exhibition catalogue, Architectural Association, London 1984

Robin Spencer, *Eduardo Paolozzi: Recurring Themes*, exhibition catalogue, Royal Scottish Academy, Edinburgh (and tour) 1984–5

Winfried Konnertz, *Eduardo Paolozzi*, Cologne 1984 (The most substantial survey, in German.)

Eduardo Paolozzi: Lost Magic Kingdoms and Six Paper Moons from Nahuati, book to accompany exhibition at Museum of Mankind, London (and tour), British Museum Publications 1985, texts by Eduardo Paolozzi, Malcolm McLeod, Dawn Ades and Christopher Frayling

Eduardo Paolozzi: Underground, exhibition catalogue edited by Richard Cork, Royal Academy of Arts, London 1986

Eduardo Paolozzi, Sculptures from a Garden, exhibition catalogue, Arts Council of Great Britain touring exhibition 1987, essay by Frank Whitford, catalogue by Caroline Cuthbert. (Documents Gabrielle Keiller's role as Paolozzi's patron.)

Paolozzi Portraits, exhibition catalogue, National Portrait Gallery, London 1988, essay by Robin Spencer

Eduardo Paolozzi: Nullius in Verba, exhibition catalogue, Talbot Rice Gallery, Edinburgh 1989, texts by Duncan Macmillan, Andrew Patrizio, Eduardo Paolozzi and interview with artist

Eduardo Paolozzi: Mythologies. A Retrospective Survey 1946–1990, exhibition catalogue, Scottish Gallery, London 1990

Eduardo Paolozzi: A Birthday Celebration, exhibition catalogue, Yorkshire Sculpture Park, Wakefield 1994

Spellbound: Art and Film, exhibition catalogue, Hayward Gallery, London 1996, essay on Paolozzi by Martin Kemp

Un Siècle de Sculpture Anglaise, exhibition catalogue, Jeu de Paume, Paris 1996, essay on Paolozzi by Jonathon Fineberg

Eduardo Paolozzi – From Munich Collections: Prints and Sculptures, exhibition catalogue, European Patent Office, Munich 1996

Eduardo Paolozzi: Artificial Horizons and Eccentric Ladders: Works on Paper 1946–1996, British Council exhibition catalogue, Talbot Rice Gallery and tour 1996, essay by Judith Collins, catalogue by Richard Riley

Duncan Macmillan, *Eduardo Paolozzi: Sculptures for the King's Buildings*, University of Edinburgh 1997

Acknowledgements

The whole Paolozzi project, from its inception through to its realisation in the Dean Gallery displays and this publication, would have been impossible but for the generosity and help of Sir Eduardo Paolozzi. We are also indebted to his assistant Nick Gorse for his detailed knowledge in reconstructing the studio and for his support throughout the last five years. A constant friend and adviser has been Robin Spencer of the Department of Art History at St Andrews University. Particular thanks are due to Katrina Thomson and Mhairi Scott who have made an enormous contribution to the cataloguing of the Paolozzi Gift.

Special thanks are also due to Judith Collins, Caroline Cuthbert and Derek Pullen at the Tate Gallery, the Conservation Department of the British Museum, Frank Thurston at the Royal College of Art, the Royal College of Art Foundry, Eva White at the Victoria and Albert Museum National Archive of Art and Design, Angela Weight and Mike Moody at the Imperial War Museum, John Larsen of the Conservation Centre for the National Museums in Merseyside, Herbert Coutts and Ian O'Riordan of the City of Edinburgh Art Collections, Jane Lindsey and Peter Black of the Hunterian Art Gallery Glasgow, Twin Watkins of the National Museum of Scotland, Gillian Jason and Benjamin Rhodes of the Jason Rhodes Gallery, Terry and Sue Farrell and colleagues at Terry Farrell and Partners, Mandy Clydesdale of AOC Ltd Conservation, Kerry and Brian Caster of Powderhall Bronze, John Chaytor of Morris Singer Foundry, Ronald J. Pepperell of T. Rogers, Adrian Barr Smith of Denton Hall, Sabina Grinling, Graciela Ainsworth, Anne Davies, Elizabeth Ogilvie, David Lyon, and Emma Paolozzi.

Our thanks are also due to all our colleagues at the National Galleries of Scotland, in particular the Registrar's and Conservation Departments. Finally our grateful thanks to Sir Colin St John Wilson, the Victoria and Albert Museum, the Tate Gallery and others who have lent to the opening display.